American Vision

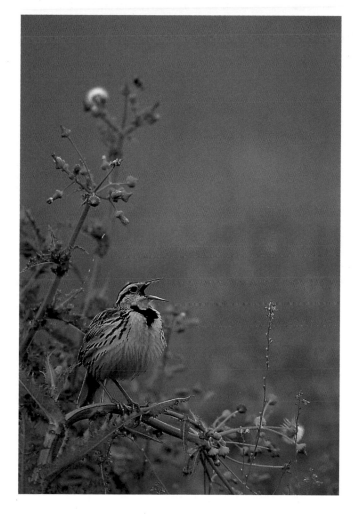

Foreword by George Lepp

With Lessons by Bill Fortney, Wayne Lynch,
David Middleton, and John Shaw

American Vision

Amphoto Books

An imprint of Watson-Guptill Publications/New York

John Shaw has written many enduring best-sellers; **David Middleton** and **Bill Fortney** are co-creators of *The Nature of America*; **Wayne Lynch** has written several books, including *A Is for Arctic: Natural Wonders of a Polar World*; and **George D. Lepp**, a senior columnist for *Outdoor Photographer* magazine, has written many nature photography books.

PICTURE INFORMATION

Half-title page: Eastern meadowlark, near Sun City, central Florida. Nikon F4, 500mm lens, Fujichrome 100. Bruce Montagne.

Title page: Monument Valley, Arizona. Canon EOS-1n, Canon 20–35mm lens, Fuji Velvia. Stan Murawski, Jr.

This book was made possible in part through the generous support of *Outdoor Photographer* magazine and Fuji Photo Film USA, Inc.

Copyright © 1999 by Over the Edge Productions
First published in 1999 in New York by Amphoto Books, an imprint of Watson-Guptill Publications, a division of BPI Communications, 1515 Broadway, New York, NY 10036

Library of Congress Cataloging in Publication Data

American vision : images by the best of today's amateur nature photographers / foreword
 by George D. Lepp : with lessons by John Shaw, David Middleton, Bill Fortney, and
 Wayne Lynch.
 p. cm.
 Includes index.
 ISBN 0-8174-3343-0
 1. Nature photography—United States. 2. Outdoor photography—United States.
I. Shaw, John, 1944– . II. Middleton, David, 1955–
 TR721.A44 1999
 779'.0973—dc21 99-20142
 CIP

Printed in Malaysia

1 2 3 4 5 6 7 8 9 / 07 06 05 04 03 02 01 00 99

Senior Editor: Robin Simmen
Editor: Liz Harvey
Designer: Jay Anning
Production Manager: Hector Campbell

CONTENTS

George D. Lepp
FOREWORD

Outdoor/nature photography is probably one of the most widely accomplished forms of today's imaging applications, second only after we photograph each other. The viewers of this book will undoubtedly be persons who have participated in some level of outdoor/nature photography themselves, and have a great appreciation for nature and fine photography. Many of us can relate to the places and subjects seen here, as well as the effort, and often luck, needed to capture them on film. Maybe the only difference between the photographers included here and yourself is the reality that they submitted their work for this publication.

The photographers whose images are represented here aren't the full-time professionals who strive each day to fill the world's need for more beautiful images to be consumed in ads, calendars, magazines, and books. These photographers are the doctors, lawyers, lab technicians, bus drivers, and housewives or househusbands who have a simple need to find, see, interpret, and record the beauty of the natural world. Some are retired from a previous skill; many aren't. Some are well along in years, while others are still being shepherded by a parent. What the photographers share is a passion—a passion that includes the out-of-doors, an appreciation for their subjects, and usually the desire to share their observations. Couple this with today's excellent photographic tools and skill levels achieved through seminars, workshops, reading, and just plain doing, and you end up with the quality and content you see on these pages.

The wonderful part about photographing nature is that the practice gives us a greater appreciation for what is happening around us. It makes us look closer at the things that so many people take for granted or are never aware of. I like to use the analogy of two groups of people visiting Yellowstone National Park. The first group is made up of non-photographers out to see and experience the wonders made known to them through magazines, brochures, and the Discovery Channel. These people will make the park loop in no more than two days (many in a single day) and motor off to other wonders of the West. They'll see gushing geysers (if their timing is lucky), beautiful scenic views (weather permitting), some bison, elk, and a chance happening of the animals. They'll purchase some postcards, maybe a book or calendar, and head home to share their adventure.

The second group is composed of nature photographers. As they make their way around the park's roads, they stop often and leave the protective shell of their vehicle to see what they might photograph up the trail and over the hill. They'll be lucky to get out of the park in a week. During their sojourn, they'll see and document the same natural phenomena as the first group. But the chances of these pho-

tographers' seeing the subjects at their peak will increase because they'll wait for the best light or the eventual eruption. Not only will they see the same bison and elk, they might very well be waiting to capture some exciting behavior, such as the nursing of a calf that had been hidden in the grass or two bulls in full sparring mode. Who knows? Maybe a wolf will materialize during the long wait for another subject. All this because of a desire to capture interesting images on film. The resulting learning experiences

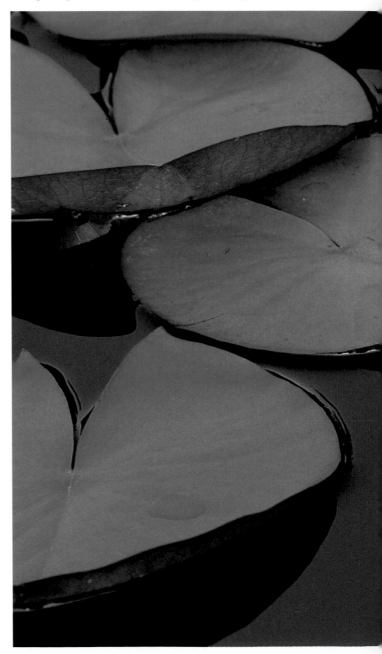

about what makes Yellowstone such a special place is a great bonus to the images taken home to be re-lived and shared with photographers and non-photographers alike.

Which group members got the most from their Yellowstone experience? Which will best communicate to their friends the beauty of what they saw and experienced? And which group members experienced the wonders of the place in the way that the founders envisioned? Photographing nature can truly open our eyes and help to share our vision.

Nature photography is a window into the natural world. The skill and creativity each photographer brings to the endeavor determine the clarity of the view. I hope this book brings you to the window. Share the view.

July, 1998

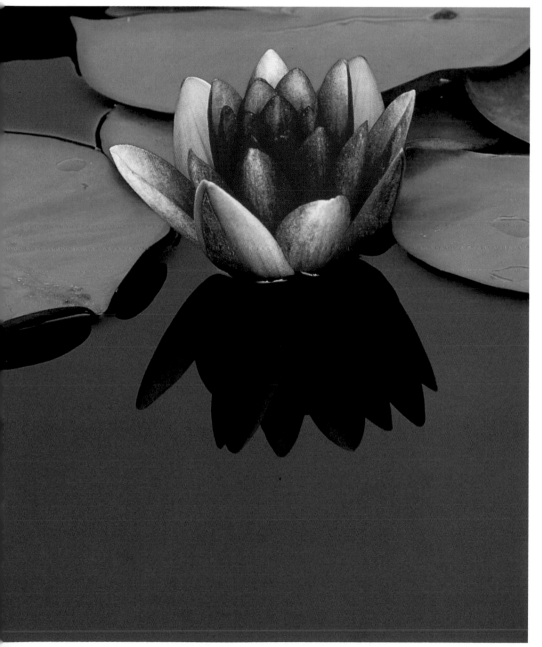

Red water lily, Purchase, New York
Nikon N90s, Nikon 60mm macro lens, Fuji Velvia
Libby Collins

Contrasts and a strong diagonal make this image work. The red flower contrasts with the cool blue-green background and balances the larger area. The texture and pattern of the leaves contrast with the glass-like water. For a tack-sharp image, I securely mounted my camera on a solid tripod.

David Middleton
INTRODUCTION

"Wow!" That has been my friends' reaction every time I've shown them the images in this book. Even though the slides have just been sitting out on my light table as they're numbered and organized before I send them off to the publisher, everyone who has seen them has been amazed. Two other comments quickly follow: "These are from amateurs?" and "David, you'd better get working to keep a step ahead of these folks."

Time for a confession. I, and all of my professional-photography peers, might not be a step ahead of the contributors to this book. We photograph and create every day and have done so for many years, and yet the photographs in this book, all made by amateurs, are as good as those any of us have ever made. And even more remarkably, amateur photographers are making images purely for the love of the craft, the love of the art, and not for some anticipated paycheck—as is often the case for professional photographers.

American Vision was created to show how good amateur nature photography is. When OTE Productions, a company I'd formed with Bill Fortney, conceived *The Nature of America* (Amphoto Art, 1997) as a showcase for professional nature photographers, Bill and I also thought about doing a companion book celebrating the best of amateur nature photography. After *The Nature of America* was published, we turned our attention to this project.

By mostly word of mouth and the support of *Outdoor Photographer* magazine, Bill and I asked all interested amateur photographers to send us their best work. For several

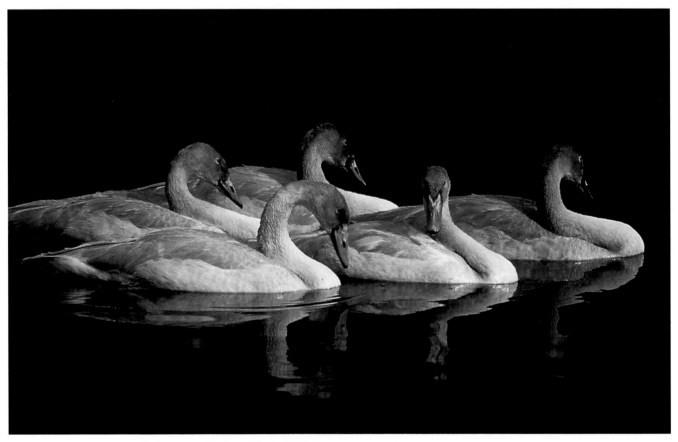

Trumpeter swan cygnets, Yellowstone National Park, Wyoming
Nikon FM2, Nikon 300mm lens, Fuji Velvia
Ken Archer

Before this seemingly content moment of peacefulness, an intensely spirited offensive occurred as a lone adult swan alighted on the Madison River near the swan family. The forested hillside darkened the portion of the river where the swans rested. Suddenly, as if by cue, a bit of sunshine broke through the clouds, enhancing the cygnets and their reflections. My telephoto lens isolated the cygnets in the dark portion of the river.

Mono Lake sunrise, California
Canon 630, Canon 120–300mm lens, Fujichrome 100
Reed Smith

I took this shot of tufa towers in Mono Lake one hour before sunrise on the longest day of the year. Since the lake's surface has risen 9 feet, these tufa towers won't be seen like this again in our lifetime.

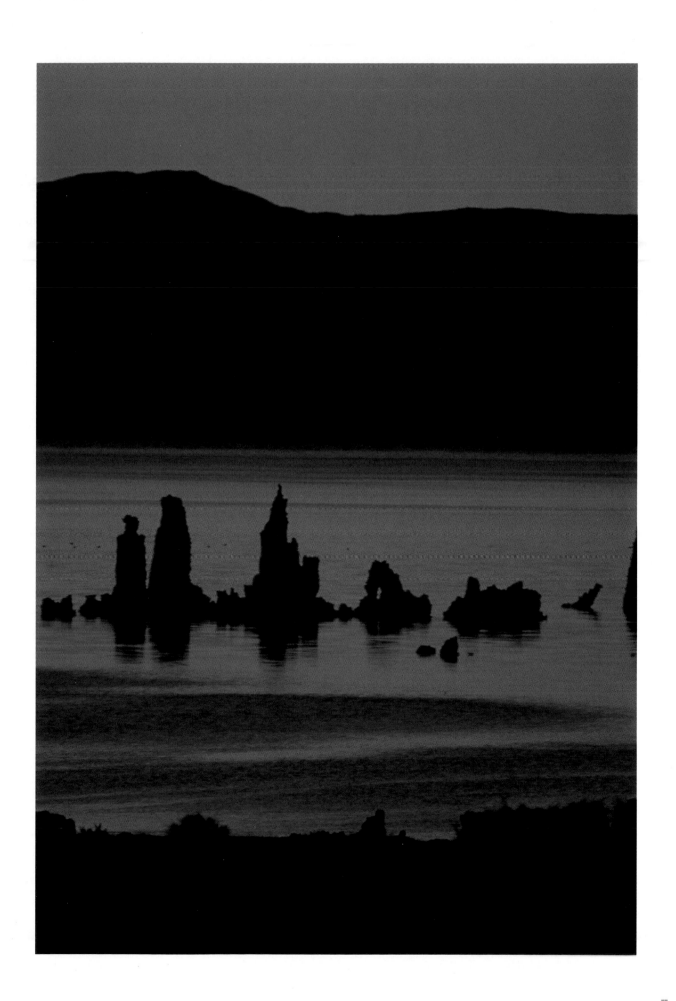

Mystic Pool, Vermillion Cliffs, Arizona
Minolta 9xi, Minolta 35–105mm lens, Fuji Velvia
John Indelicato

In order to emphasize the line and form of this formation, I composed the image from a low vantage point. To isolate the reflection and make it a strong focal point in the image, I used my 35–105mm lens.

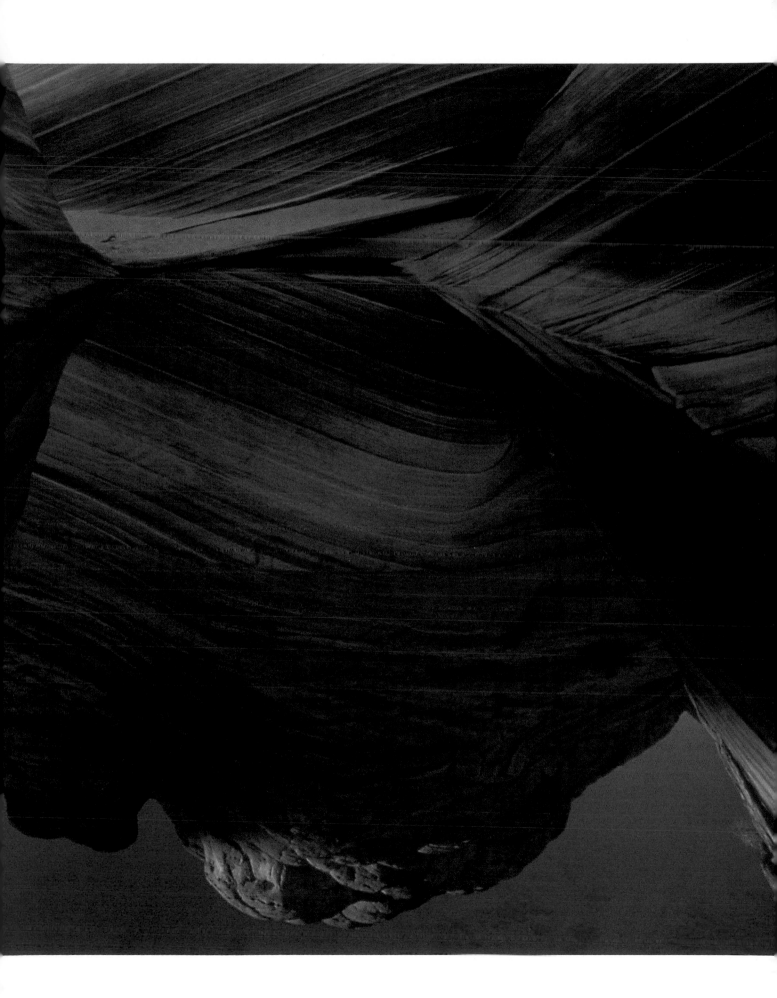

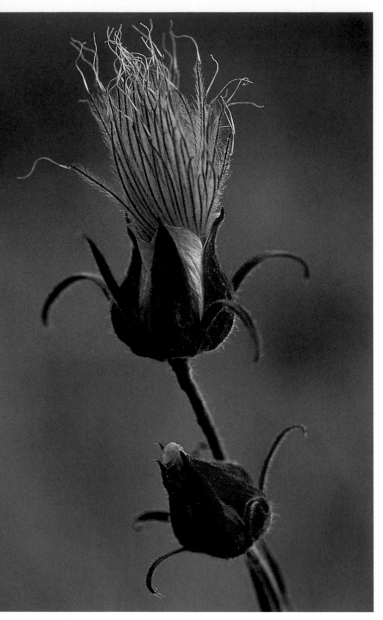

Prairie smoke, Crested Butte, Colorado
Nikon F5, Nikon 200mm macro lens, Fuji Velvia
Gail Perkins

My 200mm macro lens enabled me to isolate this blossom from the many I found along Washington Gulch Road in Crested Butte. I used a diffuser to soften the intensity of the afternoon sun.

OPPOSITE PAGE
Redwoods and rhododendrons, Lady Bird Johnson Grove, California
Olympus OM2n, Tokina 70–210mm lens, Fujichrome 100
Ursula Leschke

I took this picture in the Lady Bird Johnson Grove in Northern California. I wanted to catch the early-morning light breaking through the fog, emphasizing the contrast between the delicate rhododendrons and the redwood trees.

months the pile of images accumulated, and by the time we got around to the initial edit the stack was enormous. It took us a week to pare down the thousands of images to a working number of several hundred, and another week to do another harder edit to finalize the selection. This book would have to be a thousand pages long to show all of the wonderful photographs we received.

Deciding who to invite to help us write the essays for this book was the easiest part of the entire project. Bill and I teach well over a thousand serious amateur photographers every year, so we wanted people who were not only accomplished photographers but also accomplished teachers. Only three names came to mind: George Lepp, Wayne Lynch, and John Shaw. These three people are at the top of their profession and graciously agreed to add their words to these pages. *American Vision* is unique because no other book combines the best of amateur nature photography with the best of professional nature-photography instruction. With any more help these amateurs will soon be far ahead of us professionals!

I wouldn't mind just to keep up with all these amateur photographers. Nothing would make me happier than an annual infusion of their enthusiasm, dedication, and creative ideas. Nothing except, perhaps, relabeling these slides with my name and claiming them as my own. I have 100,000 slides in my files and yet there isn't an image in this book that I wouldn't love to have as my own. Perhaps I should start working a bit harder!

In the past I've tried several times to shoot photographs of my own like some of these in this book, but I've never been quite as successful. Although I used to hike in Pennsylvania's Ricketts Glen State Park, I never got a picture of the waterfalls that looks anything like Scott Brown's (see page 77). I've also spent days photographing redwood trees and have wandered all over the Lady Bird Johnson Grove in Redwood National Park, but—I hate to say it—my best flowering-rhododendrons-in-the-forest shot isn't as good Ursula Leschke's (see opposite). I love pine cones; I have them in my car and all over my office. So, as you might expect, I have lots of shots of pine cones on the forest floor. But I have nothing as good as Barbara Warren's pine-cone shot (see page 81). And I was photographing with Gail Perkins, or at least near her, when she took her picture of the prairie smoke wildflower (see left). Not only do I not have anything as good as her shot, it didn't even occur to me to try to duplicate her shot after she took it!

While I might seem frustrated by all of this, it actually encourages and motivates me. This book is clear evidence that the quality of an image in no way separates the amateur from the professional photographer. These amateurs are good, and they inspire me to be better. The next time I'm out photographing, I'll look a little harder, not be in such a big hurry, and think again about the stuff I'm walking past. I also guarantee that I'll pay more attention to what my workshop participants are photographing.

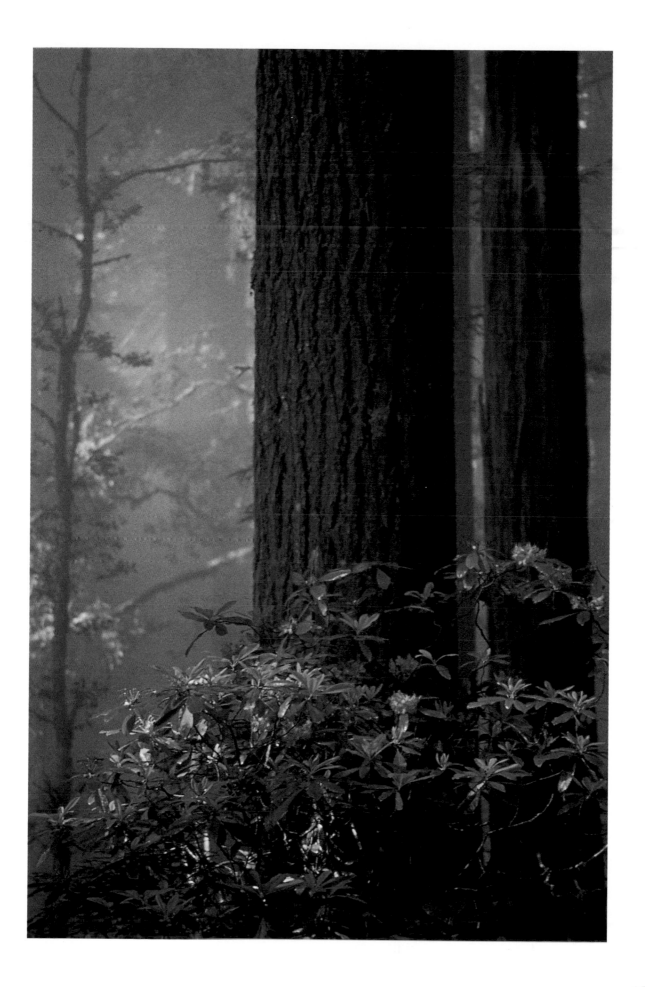

Monument Rocks, Oakley, Kansas
Nikon F4, Nikon 24mm lens, Fuji Velvia
Bill Castner

While driving through western Kansas I made a snap decision to try and find Monument Rocks. It was late in the day when I found the location; the light was fading fast. I had just enough time to make this and two other exposures before the sun went down.

RIGHT
Pack ice reflection, Alexandra fjord, Ellesmere Island
Nikon F3, Nikon 300mm lens, Kodachrome 64
Roy Hamaguchi

Around 1 A.M. I came upon a series of pack ice formations. There was just sufficient light to shoot standing from a Zodiac. I managed a single shot before a breeze came up again and the reflection disappeared.

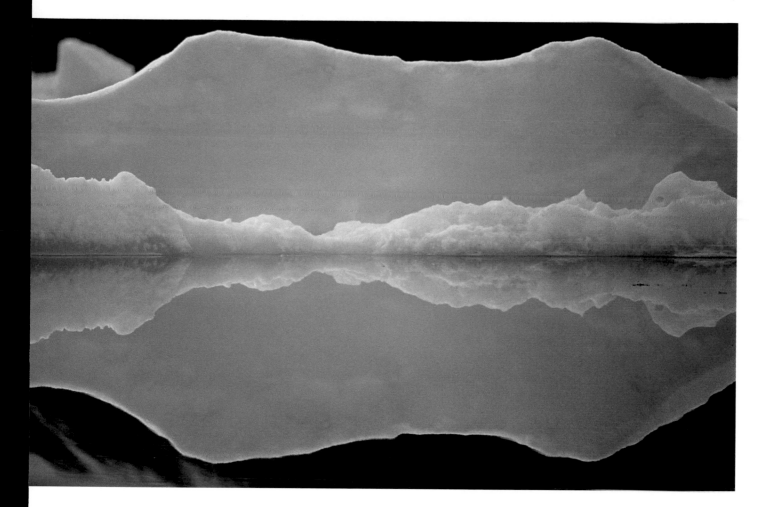

Many of the images in this book inspire me. I think Roy Hamaguchi's photograph of the pack ice reflection is astoundingly beautiful (see above), as I do John Indelicato's shot of Mystic Pool (see pages 10–11). I find it reassuring that such exquisite places still exist. And I definitely want to meet the spider that spun the web that Ted Nelson so magnificently captured. Either this web was woven underneath the window of a Euclidean geometry class or it is at last proof that aliens (with six legs!) have landed on earth.

The images in *American Vision* make me want to be where the photograph was taken—with or without my camera—even if it is just to experience the moment. I would have loved to have seen the morel mushrooms and violets that Richard LaMartina found (see page 81), the water lilies Libby Collins photographed (see pages 6–7), and the swan cygnets Ken Archer saw in Yellowstone National Park (see page 8). That is the magic of nature photography, and more broadly the power of art. It doesn't matter if the image was created by an amateur or by a professional; it is the ability of the image to touch and to transport the viewer that is important.

Should I begin to tell you the number of times I've walked by a garden of sunflowers but never saw what Eva Kahn saw and photographed (see page 135), or driven through Kansas with my eyes locked on my odometer and not seen the Monument Rocks that Bill Castner photographed so well (see opposite)? How long do you think it will take me now to find the nearest sunflowers or locate those rocks on a map of Kansas? I hope you do the same.

To choose the ordinary and make it extraordinary is the very essence of nature photography. I thank all of the contributors to this book for reminding me of that.

I'm also reminded that while most of the world is looking one way at what is standard and to be expected, others, with their backs turned to us, are looking at (and photographing!) the unexpected. Who else but a nature photographer would go to Mt. Rainier National Park and photograph flowers and ferns and not the big white mountain looming in the distance? And who else would go to Grand Teton National Park and photograph reflections when geysers and towering peaks are overhead? I want to thank all of the amateur photographers whose images grace the pages of *American Vision* for looking elsewhere and finding beauty in the overlooked and unappreciated.

I hope you find this collection of the best of amateur nature photography to be as beautiful, inspirational, and magnificent as I do. Let it be a reminder of the creative potential that lies within all of us and of all the beautiful photographs that have yet to be made. Now, grab your camera and go out and get some photos!

John Shaw

EQUIPMENT ESSENTIALS

Nature photography is equipment-dependent. That statement is obvious: you can't produce any photograph at all without at least some equipment. But the corollary that would seem to follow—that only good equipment can produce good photographs—isn't totally true. You can make great photographs with any camera so long as your photo technique, or how you work with your equipment, is good. The better your technique, the better the technical aspects of your photographs will be.

However, I would strongly encourage you to purchase the best equipment you can afford because your photo life will become easier when you use well-designed, user-friendly, reliable, quality equipment. When buying lenses, you should always get the best. Why? A limiting factor in the quality of any photograph is the quality of the lens used. An image on film can be no better than the image projected onto the film by the lens. A quality lens offers a quality image. Besides, once you own the best equipment you have no one but yourself to blame or credit when your images turn out well or fail miserably.

Just remember that no lens by itself produces pictures. Owning the best quality lens means only that you can afford good equipment. No lens goes out by itself and shoots pictures. Equipment alone doesn't make photographs. And while you might need certain equipment in order to shoot specific pictures, how you use the equipment is far more important. The very best photographic equipment used haphazardly will produce sloppy results. Middle-of-the-line equipment used with care and precision is capable of producing flawlessly exquisite results. The photographer using the equipment is still of prime importance.

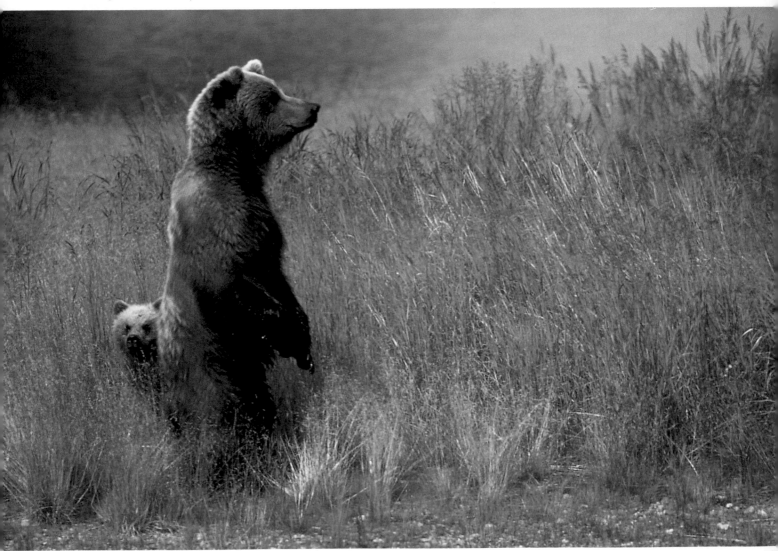

Of course, most of us who have become addicted to taking pictures also tend to be addicted to owning equipment. We succumb to the false belief that if only we could purchase another lens or the latest camera body, our photographs would show a vast improvement. In truth, owning more equipment in general means just exactly that: more stuff to carry in the field—or, more likely, more equipment to sit at home in your closet because you can't carry everything.

CHOOSING THE RIGHT EQUIPMENT

With all this in mind, you might be wondering what equipment you really need for nature photography. While a lot depends on the subject matter you want to photograph, whether it is the grand landscape or wildlife action or tight closeups, I recommend starting with a 35mm single-lens

reflex (SLR) system. Photographers should certainly consider other formats as their interests develop, but 35mm cameras are popular for good reasons. They are fairly easy to use in the field under most weather conditions, are reasonably affordable both to purchase and to operate, are easily obtainable, have a wide variety of film choices available, and offer many lens options. Best of all, 35mm cameras can be used to photograph subjects ranging from the broad scenic landscape down to extreme closeups. Indeed, the vast majority of images in this book were taken with 35mm SLR cameras.

Once you are serious about your photography, you'll want to get certain camera features, you'll make a number of lens choices, and you'll find that you might want to purchase some optional items of equipment. Here is my overview on camera essentials.

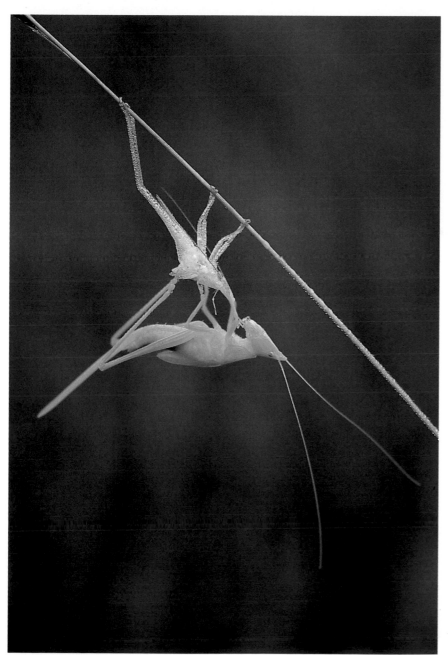

Katydid molting, Richmond, Virginia
Canon, Canon 100mm macro lens, Fuji Velvia
Chuck Janus

I donned my chest waders and was wading toward the swamp's edge when I spotted this katydid in clear view. I shot at f/8 to accommodate a gentle breeze and diminish the distracting background.

OPPOSITE PAGE
Brown bear with cub, Katmai National Park, Alaska
Nikon 90s, Nikon 50mm lens + 1.4X teleconverter, Kodak E100S
L.F. Van Landingham

I watched this large, female brown bear and her spring cub for several minutes as they fished for salmon in the shallow waters of the Brooks River in Katmai National Park. Suddenly the mother sensed danger and stood up to look around. The cub peeked around her, and I fired away.

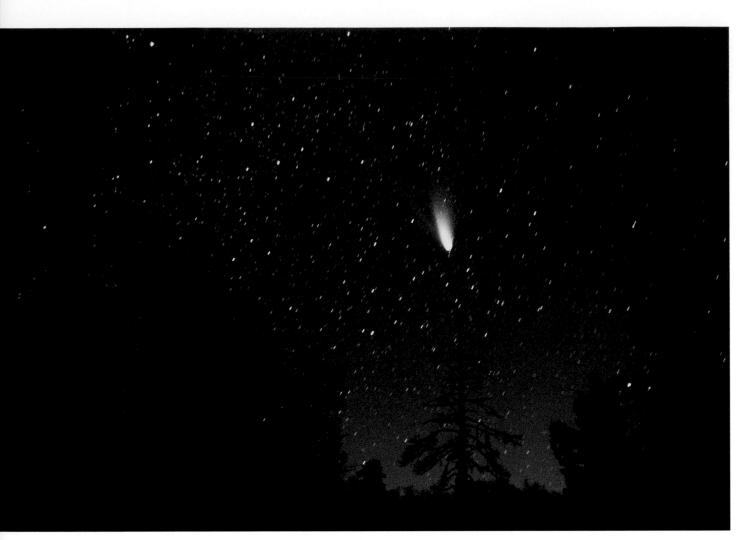

Hale-Bopp Comet, Laguna Mountain, California
Nikon Nikkormat, Nikon 50mm lens, Kodak EPH rated at ISO 1600
Steve Shuey

I took this photograph at approximately 4:30 A.M. from the ski resort at Brianhead, Utah. I exposed for 60 seconds on Kodak EPH film rated at ISO 1600, using a 50mm lens set at f/2.

TOTAL EXPOSURE CONTROL

If you want to be in control of your photography, you must be able to control the exposure precisely as you want it to be. This is imperative when you're shooting transparency films since they have little tolerance for incorrect exposure. I'm not suggesting that you have to use a camera where you manually set the exposure, although most modern cameras allow you to do this in addition to their "automatic" settings. In truth, manually setting the exposure is exactly how I generally use my newest, most advanced cameras. Given a choice, I would purchase a camera that offers half-stop—or better yet, third-stop—increments when you manually set apertures and shutter speeds.

If you do want to use a full autoexposure mode, make sure the camera offers an easily adjusted exposure-compensation system. At the very minimum the camera should provide two full stops of compensation on either side of the metered value. That is, from the metered value there should

be at least two stops in the "plus" direction and two stops in the "minus" direction. You should be able to set these exposure compensations in half-stop or third-stop increments, as full-stop autoexposure changes are far too broad for the fussy, narrow-latitude slide films. Ideally the compensation settings should be visible while you look through the viewfinder; otherwise you'll quickly discover just how easy it is to make mistakes.

Most current cameras now offer a full range of shutter speeds, from around a blistering 1/4000 sec. or so down to around a full 30 seconds. Great! The broader the range of timed speeds the better, although you'll probably never use the ultra-fast shutter speeds. Most of the photographs in this book were taken at about 1/250 sec. or slower. My own cameras offer a top-end speed of 1/8000 sec., but I've never used it and most likely never will. For that matter, I've never used the 1/4000 sec. or 1/2000 sec. shutter speeds either.

Sunset, Great Smoky Mountains National Park, Tennessee
Canon A2, Canon 75–300mm lens, Fuji Velvia
Ian Plant

I used a two-stop, graduated neutral-density filter for this shot in order to balance the exposure between the sky and the mountains. This enabled the film to record the reflected light striking the mountains, giving them a magenta hue.

Why aren't these speeds so important? An old but true statement about films is that as film speed, or the ISO index number, goes up, the quality of the image goes down. Consequently for the best results, you want to use the slowest film you can, given the light in which you're photographing and the subject you're shooting. Right now films in the ISO 50–100 range are the most popular as they offer a combination of speed, sharpness, and color saturation. But suppose you're using an ISO 100 speed film in the field. Even in blazing sunlight, which is definitely not a preferred lighting situation, the base exposure for this film is 1/1000 sec. at *f*/5.6. You are far more likely to use this exposure, with a little leeway in terms of depth of field, than the equivalent 1/8000 sec. at *f*/2. Actually if you're shooting landscapes or closeups, you'll always be stopping the lens down to around *f*/16 for more depth of field. Now in that same brilliant sunlight, the correct shutter speed at *f*/16 is 1/125 sec. But who shoots at high noon? Work in the good light of early morning and late evening, and you'll find that long shutter speeds, running into the multiple seconds, are the norm.

DEPTH OF FIELD PREVIEW

For serious field work, you must be able to stop your lens down to a shooting aperture by using the depth-of-field preview or stop-down control. This lets you evaluate exactly how the depth of field will appear while you're viewing through the lens, before you ever press the shutter release.

Remember that under normal conditions you're viewing through your lens at its wide-open aperture. So, for example, when you shoot with an F2.8 lens, you're viewing through the lens at *f*/2.8 even though you might be working at *f*/11 or *f*/16. There is a big difference in depth of field between what you see in the viewfinder at *f*/2.8 and what the film sees at *f*/16. Press the preview button, and you'll see what the film sees.

Cattail leaves, Washington
Nikon N8008s, Nikon 105mm macro lens, Fuji Velvia
Rod Barbee

While I was looking for red-winged blackbirds near my home, these backlit cattail leaves caught my eye. I kept the film plane parallel to the subject to maximize depth of field. Revealing fine details of a subject and discovering the simplicity in an image are two reasons why I enjoy closeup photography.

Bee on thistle, Pepperell, Massachusetts
Olympus OM1, Tokina 80–200mm lens + Nikon 6T closeup lens, Fuji Velvia
Eric Jamison

One cool August morning I photographed this bumblebee, covered with dew and pollen, hanging from a thistle. I used my 80–200mm lens with a Nikon 6T closeup diopter plus 20mm of added extension.

OPPOSITE PAGE
Grand Canyon, Yellowstone National Park, Wyoming
Nikon FA, Nikon 28–45mm lens, Fuji Velvia
Jim Perdue

I took this picture from the brink of the lower falls in the Grand Canyon in Yellowstone. I used my wide-angle zoom lens set at 28mm to capture the mist rising from the roaring waterfall along with the river winding off through the canyon.

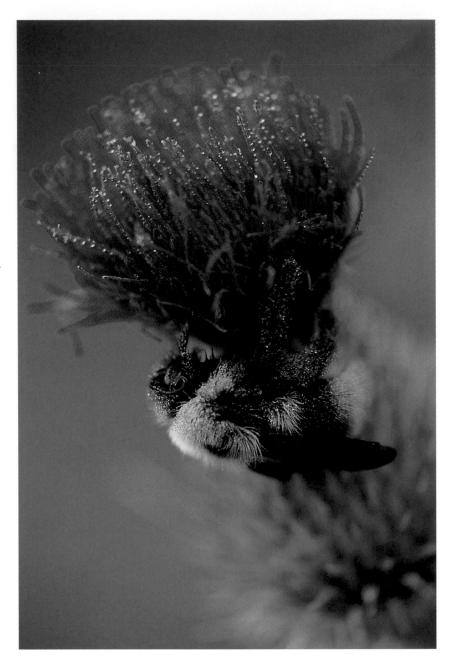

LENSES

Interchangeable lenses are one of the joys of the 35mm SLR camera design. Lenses are available from the ultra-wide to the ultra-telephoto—and I never met a photographer who didn't want at least one more lens. For most general nature photography, focal lengths from 20mm or 24mm to about 300mm will suffice. If you want to photograph birds and mammals, then you'll definitely need a longer lens. I suggest a 400mm lens for large mammal photography, a 600mm for bird work, and a 500mm for an all-around lens.

Today most focal lengths can be covered with zoom lenses. The ability to compose precisely as you want the image to appear is reason enough for a zoom lens. New zoom-lens designs are fantastic both in their focal-length range—anything and everything seem to be available—and in their quality. A two- or three-lens outfit can give the field photographer most focal lengths. Some possible combinations are a 28–80mm and a 70–300mm. Another grouping comprises a 28–70mm, an 80–200mm, and a fixed-focal-length 300mm. Or perhaps a 20–35mm, a 35–70mm, and an 80–200mm combination. The possibilities are staggering. Once you get past the 300mm focal length, there really are few zoom possibilities, and in truth at this point I recommend sticking with fixed-focal-length lenses. One reason is lens speed, or the maximum aperture of a lens. For general nature photography you really don't need ultra-fast lenses, ones with wide-open apertures of F2 or F1.4. After all, how often would you ever work at these *f*-stops? You'll almost always be stopping down to gain depth of field. Sticking with medium-speed lenses will save you money and weight.

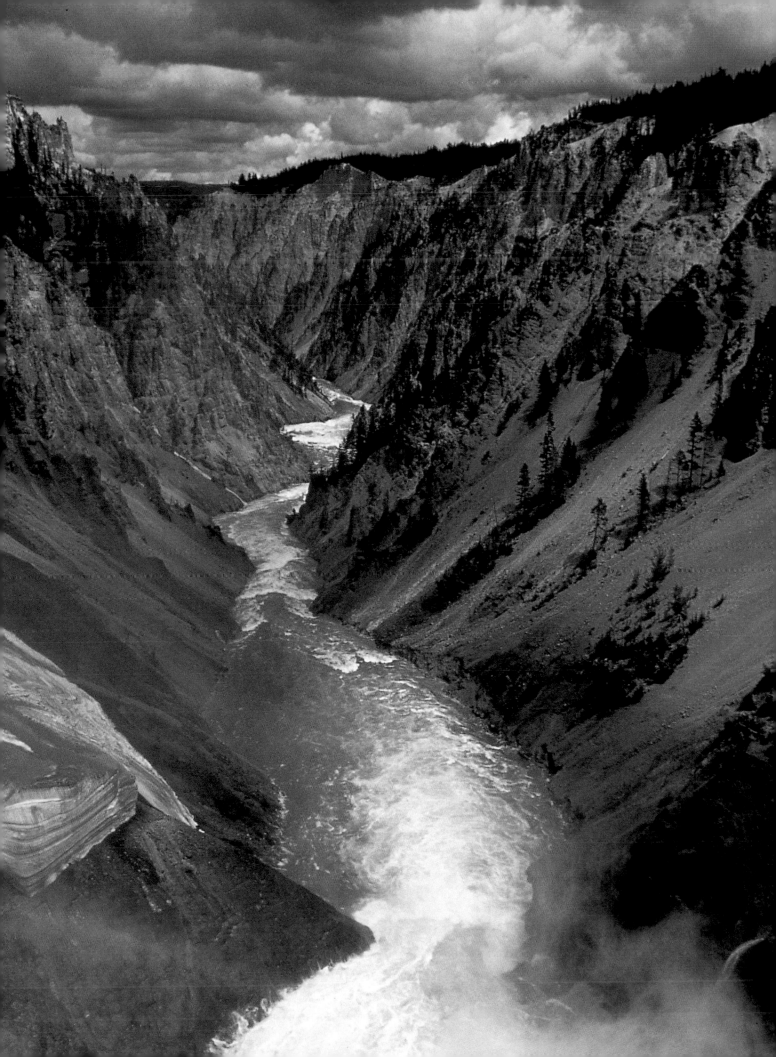

Alaska Range sunset, Denali National Park

Nikon N90s, Tamron 70–300mm lens, Fuji Velvia

Richard Worthley

At sunset an orange glow appeared and illuminated the Mt. McKinley range. I used my zoom lens set at approximately 135mm with a Tiffen enhancing filter to capture this image.

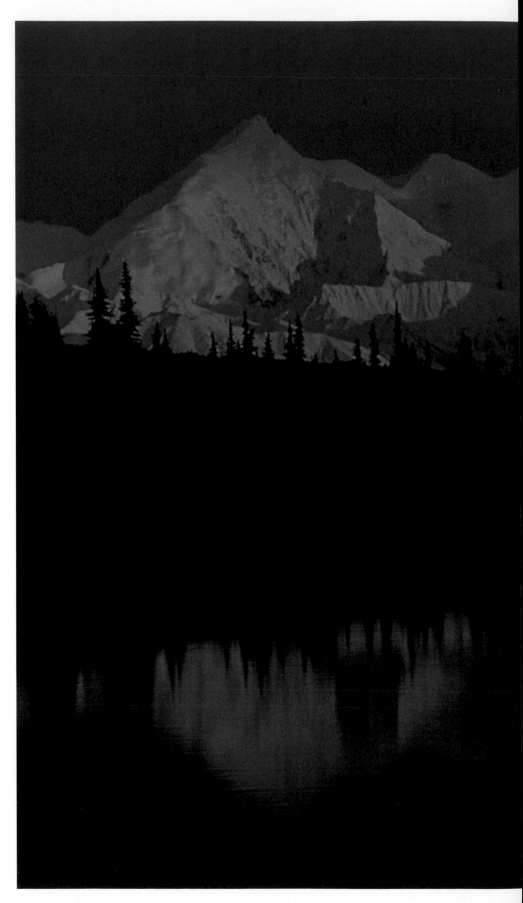

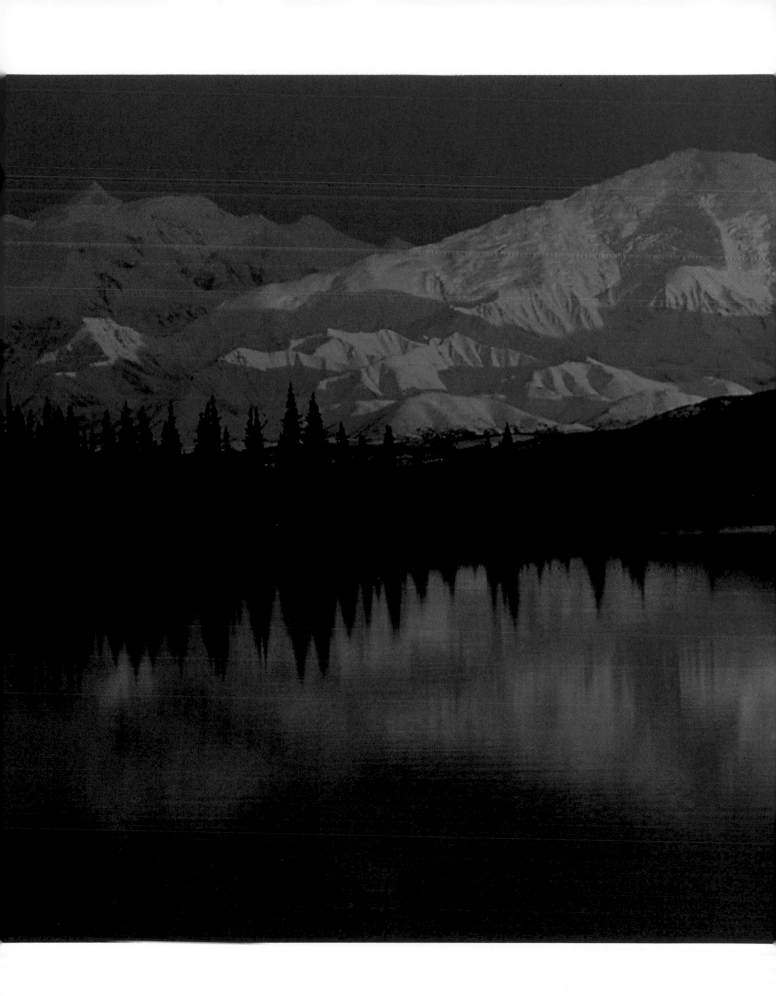

But you tend to use long focal lengths at their wider apertures since generally you're trying to keep the shutter speed up in order to stop subject motion. A 400mm lens that is F8 wide open isn't very useful compared to a lens of the same focal length that is an F4. This would permit shooting two stops faster. For example, the F4 lens would allow you to shoot for 1/250 sec. rather than 1/60 sec. This is a big difference. The few long-focal-length zooms available tend to be slow at their long ends. Buy a fixed-focal-length long lens.

TRIPODS

Probably the very best accessory to improve the technical quality of your photography is a sturdy tripod. A good tripod lets the absolute quality of your lenses show up on film. I would dare say that almost every photograph in this book was taken with the camera firmly mounted on a tripod. An old rule of thumb is that you can generally get acceptable results handholding a lens if you use a shutter speed at least numerically equal to the lens' focal length. In other words to successfully handhold a 100mm lens, you need to shoot for 1/100 sec. at a minimum. If you use a 200mm lens, the shutter speed will increase to 1/200 sec. Consequently, if you insist on handholding a camera, you'll be restricted to working in bright light with fast film and short lenses. Otherwise you'll have to start referring to those out-of-focus shots you get as "art."

The solution is simple: buy and use a good tripod. In terms of nature photography, not all tripods are suitable. You need a dependable, rock-solid, fairly tall (to compensate for working on uneven terrain) tripod that also goes quite low to the ground. Phew . . . that's some bill to fill. But there are exactly such tripods available. The following is a list of models to consider. Your final choice will be determined by: how long a lens you plan on using (the longer the focal length, the sturdier and more massive the tripod should be), how much money you can spend (knowing that this is the best accessory you can purchase), and just how much weight you're willing to carry.

• Manfrotto (Bogen) 3021 or 3221. The same tripod, in either a chrome or black version. For the amateur photographer, the best buy for the money.

• Gitzo 340, 320, and 410. Super-solid, dependable, and heavy. Most professional photographers use Gitzo tripods.

• Gitzo G1348. Carbon-fiber legs, lighter in weight than other Gitzo tripods, but expensive.

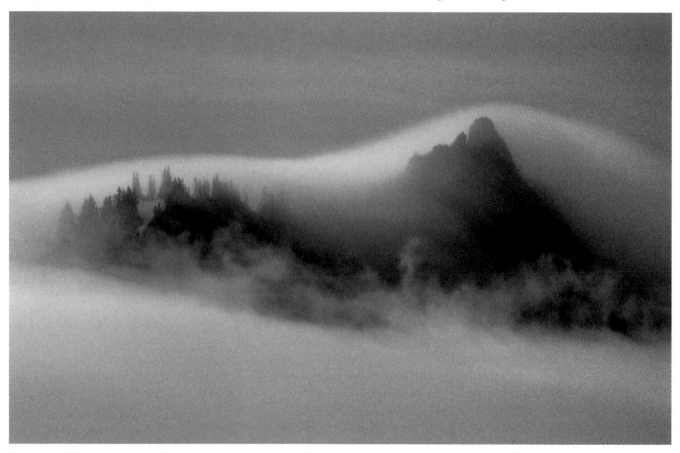

Hurricane Ridge and clouds, Olympic National Park, Washington
Canon EOS-1n, Canon 70–200mm lens, Kodak E100SW

Steve LePenske

I photographed this quiet image with my zoom lens at the 200mm setting. I used a Gitzo 1228 tripod with a Studioball head. I didn't bracket or use the mirror lockup.

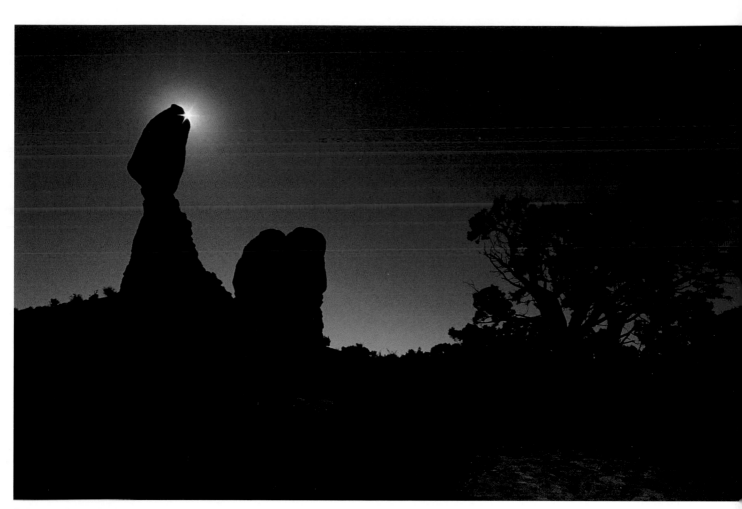

Balanced Rock, Arches National Park, Utah
Minolta XD11, Tokina 17mm lens, Kodak E100SW
Clyde Parrott

In order to get close enough to place the sun behind Balanced Rock, I had to use a wide-angle lens. I chose the lens' smallest aperture to enhance the starburst effect since the edge of the sun barely emerged from the rock. No filter was used.

Add a good ball head, such as the Kirk BH-1, the Arca-Swiss B-1, or the Graf Studioball. I strongly suggest purchasing the quick-release version of these heads. All are available with the same dovetail clamp and plate quick-release system. This is the so-called "Arca-Swiss design," which has become the de facto professional standard. Of course, you'll also want a quick-release plate attached to each camera body and lens collar.

A quality tripod is also a great help in the aesthetic side of photography. With the camera firmly locked into position, you can study your composition, determine exactly where you want the edges of the frame to fall, and carefully check for hot spots or detracting elements. Using a tripod for landscape and closeup work slows you down, making you more studious in your approach. The more care and precision in setting up the shot, the better your results will be.

OTHER ACCESSORIES
A few other general accessories are quite useful for all nature photographers:

- A 1.4X teleconverter to give your long lens an even longer focal length.

- An 81A filter and a polarizing filter for all your lenses.

- At least one extension tube.

- A notebook and a Sharpie permanent marker.

- A jeweler's screwdriver and needlenose pliers.

- Folding diffusers and reflectors, such as the Photoflex Lite-Disc line of products. Get the largest diffuser you can—Photoflex calls this a "white-white" disc—so that you can control the light both on the subject and on the background, and a couple of the small, 12-inch white/gold reflectors.

The photographs in this book have been taken by photographers with vision, using good equipment and careful photographic technique. By purchasing the right equipment, learning compositional techniques, and developing your own style, you, too, can make great pictures.

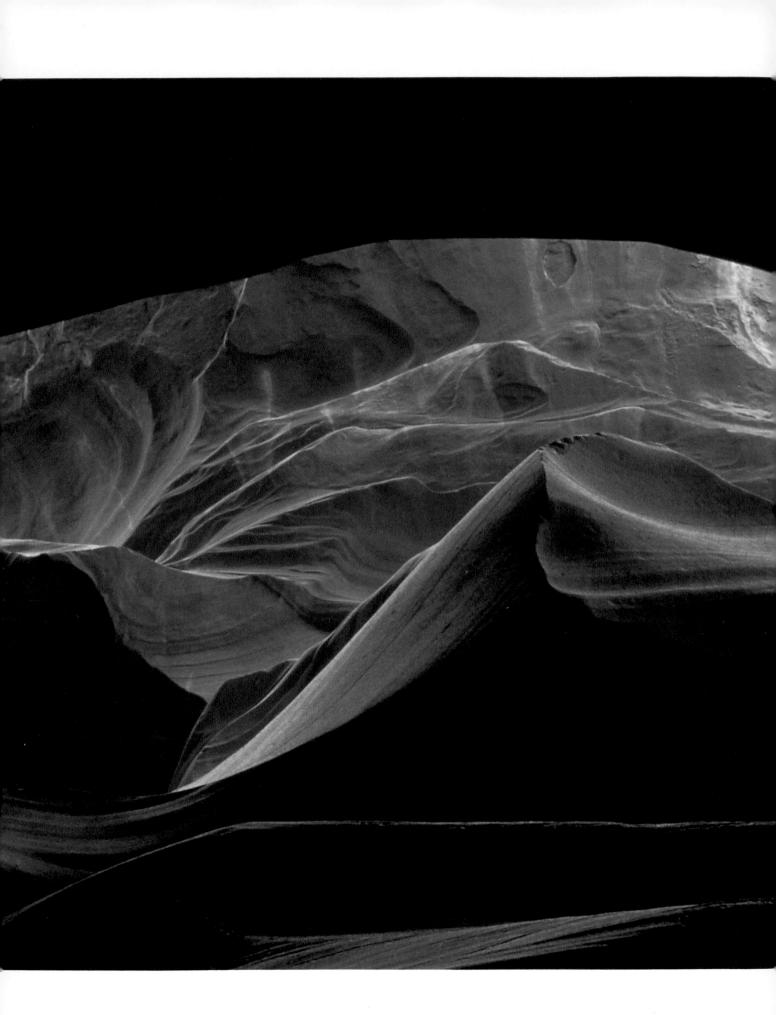

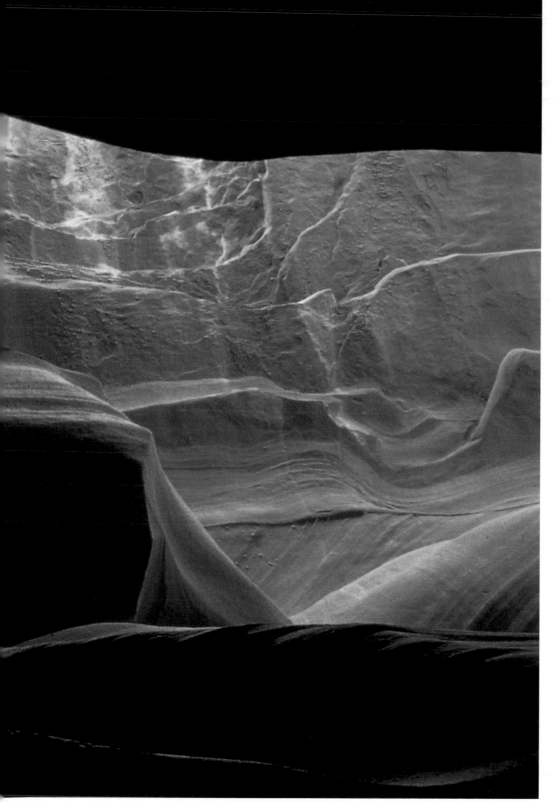

Sandstone abstract, Antelope Canyon, Arizona
Nikon F5, Nikon 35–105mm lens, Kodak E100SW
Ron Smith

While shooting Antelope Canyon, I attempted to visualize how the light bouncing off the rock walls from above would highlight and color graphic designs in the sandstone. The low light and cramped space in the canyon required a long exposure on a tripod wedged in place.

David Middleton
COMPOSITION

There seems to come a point in the development of every photographer when the concept of inclusion becomes all important. It is no longer enough to just take a picture of something. Suddenly photographs have to be framed by overhanging branches or taken through window frames, or odd parts of shrubs or grasses must be added to the bottom, or—my favorite—a big chunk of blank, white sky is thrown into the top of the composition because "Well, you always have to include the sky."

Actually, you don't have to add anything to your composition. You don't have to include the sky or the nearby branches. You don't have to frame your viewfinder with whatever ornamentation happens to be close by, and you don't have to include grass, dirt, bushes, or whatever happens to be at your feet. As a matter of fact, it is almost always better if you don't haphazardly add stuff to your shot. Most of the time, including more stuff in your composition detracts from your photograph. Adding actually subtracts from your photograph.

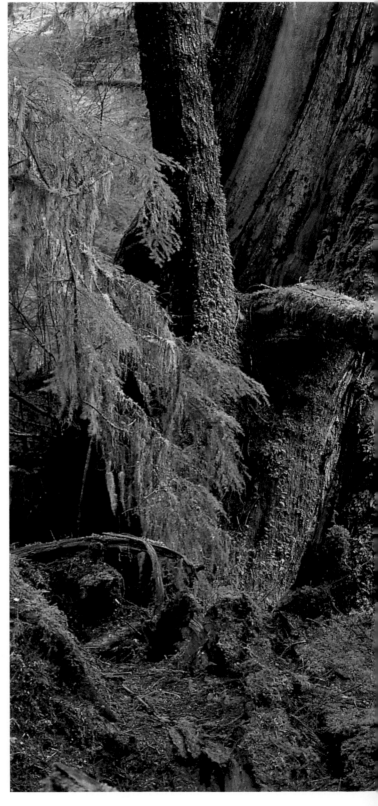

Green kalanchoe leaves, Marie Selby Botanical Gardens, Sarasota, Florida
Nikon N8008s, Nikon 75–300mm zoom lens with extension, Fuji Velvia
Linda Vannetta

By adding a 52mm extension tube to my 75–300mm lens, I was able to move in close to these kalanchoe leaves. In this way the graphic elements of color and shape become prominent.

RIGHT
Big cedar tree, Queen Charlotte Islands, Canada
Canon FI, Canon I00mm macro lens, Fuji Velvia
Ian Gould

Images that convey relationships hold power. Here I saw the two elements, then combined them. The lens was incidental; anything focal length from 85mm to 135mm would have worked.

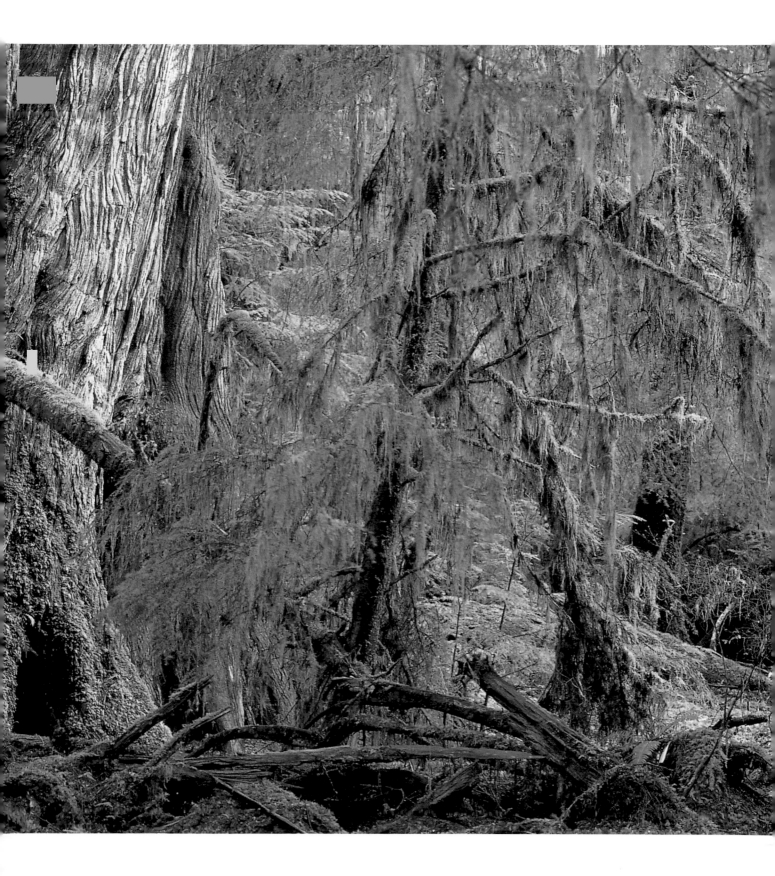

LESS IS MORE

How can this be? Isn't more better than less? Doesn't a photograph with lots of stuff in it give the viewer more things to look at? Isn't the object of a photograph to capture the entire scene in one shot? Isn't this why wide-angle lenses are so popular for landscapes—the wider the better. Why use a 35mm lens when you can get more of what is in front of you on film with a 24mm lens?

When it comes to photographic composition, less is better. Here is why. The less you include in a photograph, the more obvious it is for the viewer to know exactly what you liked about the scene. Conversely, the more you include in the picture, the less sure the viewer is about what captured your eye. "Did he like the sky . . . or that stuff on the right? Why are those branches hanging there? Is that what he liked?"

Good composition is a clear representation of your creative vision. There should be no question as to what attracted your eye. A well-composed photograph should make the very clear statement "This is what I liked." If the photograph also happens to please other people, then all the better. But you should please yourself first and worry about everyone else later.

Think of it this way. A good composition is a phrase: compelling, concise, and well constructed. A bad composition is a paragraph, and a terrible photograph is an entire book. If you take a picture of everything, your little phrase is lost somewhere within that paragraph, hidden by the visual clutter you decided to add to your initial creative vision. All the other words of that paragraph are obscuring and diluting that wonderful little phrase. Your viewers don't know which of the phrases you liked in the paragraph you photographed. They won't have a clear idea of what your creative vision was. The result won't be a good photographic composition.

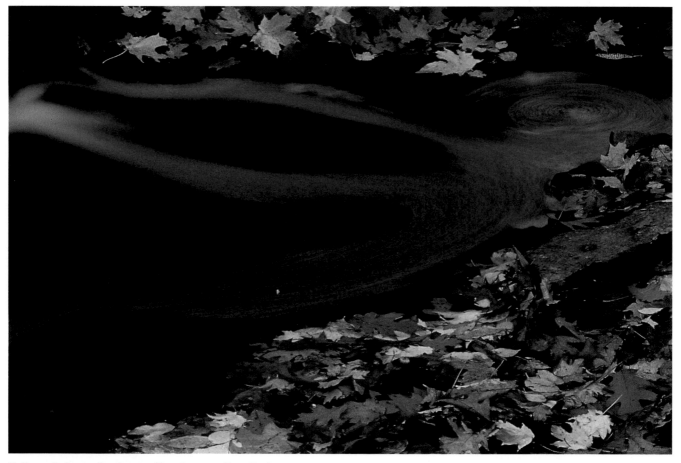

Fall maple leaves in stream, Chautauqua, New York
Nikon N90s, Nikon 105mm macro lens, Kodak Lumiere X
Judy Norton

The rich saturation and contrast between the wet leaves and the dark, rich bank drew me. To get the sharpness I wanted and to compose my image simply, I used my 105mm macro lens.

Snow-covered trees, Northern California
Canon EOS, Canon 100–300mm lens, Fuji Velvia
Ky Schroeder

While driving up Mt. Shasta to take pictures after a storm, I glanced in my rear-view mirror and saw this shot. I used my 100–300mm zoom lens in order to crop the image as I wanted it to appear.

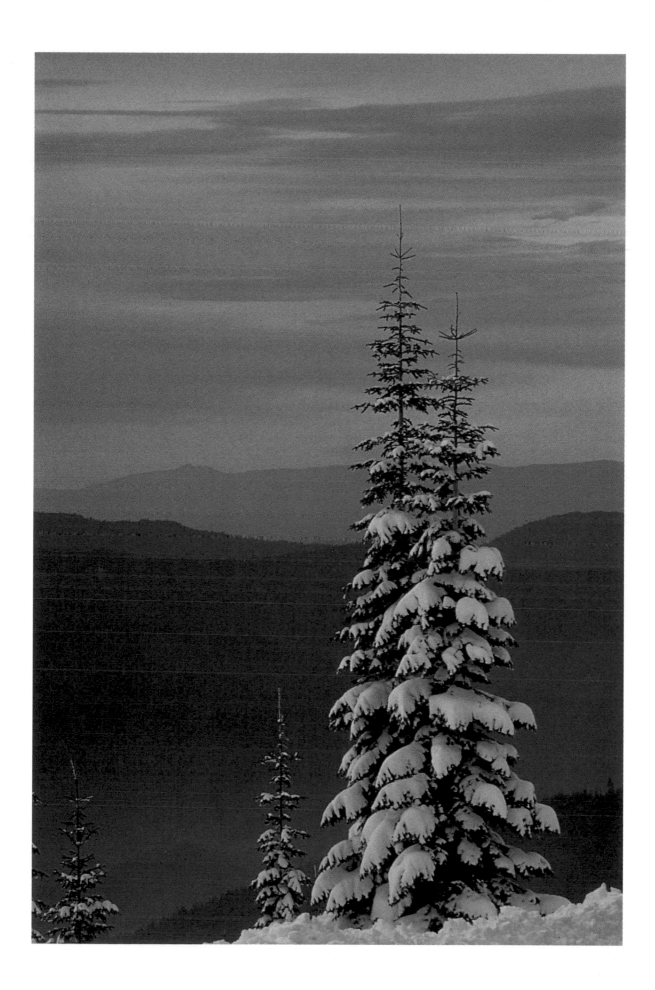

IDENTIFYING A COMPOSITION

So how do you photograph a phrase? First, ignore the inclusion monster that lurks within and is always telling you to add more. In part, that monster feeds on your lack of confidence that what you think is worthy of a photograph someone else will as well. Who cares what someone else thinks?! Are you photographing to please someone else, or are you photographing to first please yourself? Stand up, and hold your head high. When you show someone else your photographs, think "This is what I liked, and it is the best I could do. If you don't like it, that's okay. But I like it, and that's good enough for me." Remember, even the most celebrated photographs have their detractors. That is why photography is called art; some people will like it, and some won't.

The second step is to ask yourself exactly what it is about a scene that you do like. Do this out loud if you have to. No one ever said muttering isn't allowed. I mutter all the time; it helps me refine my creative vision. The trick is your answer should be as short and precise as possible. If you answer, "I like the flowers against the rock," then photograph only the flowers against the rock. Don't photograph the trees behind the rock, the grass in front of the rock, the flowers off to the side of the rock, or the dirt on top of the rock. Photograph just the flowers against the rock. That is your phrase. That is your good composition. If you include the trees, the grass, the other flowers, and the dirt, you'll build a visually cluttered paragraph in which your phrase is lost.

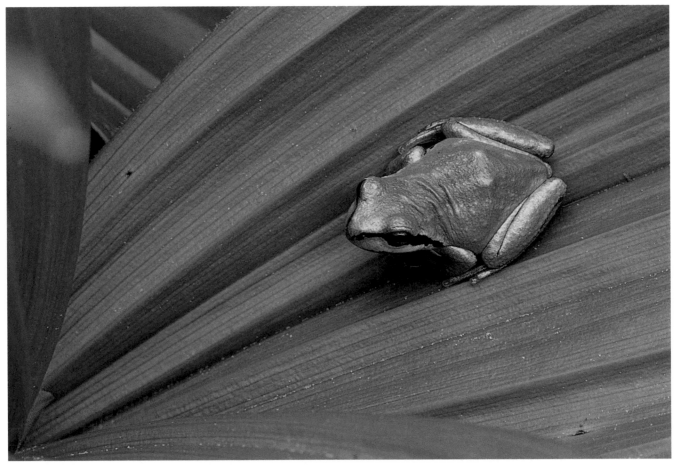

Pacific tree frog on California corn lily, Gifford Pinchot National Forest, Washington
Pentax LX, Pentax 200mm lens + extension tube, Fujichrome 50
John Kingsolver

In spring, along a slow-moving stream dotted with beaver ponds, the California corn lily is up and beginning to open its leaves. Frogs are everywhere and occasionally will use these leaves to rest on. Usually the frogs will jump off if approached too closely. This one didn't seem to mind my presence even when I used my hand to block out the sun to cut down on contrast.

**Dew-covered spider web and grass,
Highland State Recreation Area,
Michigan**
Pentax LX, Pentax 100mm macro lens,
Kodachrome 25
Ted Nelson

I thought I was finished with a morning
photo session. But as I walked up the
slope, out of a bog, I noticed the unusual
shape this dewy spider web formed. All I
did was aim and shoot. It seemed so
easy!

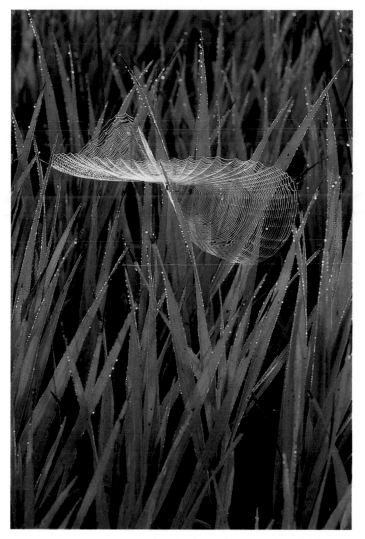

**Bamboo, Marie Selby Botanical
Gardens, Sarasota, Florida**
Nikon N8008s, Nikon 75-300mm lens, Fuji Velvia
Linda Vannetta

To compress this stand of bamboo at the
Marie Selby Botanical Gardens and make it
appear denser, I used my 75-300mm lens set
at 300mm. I also focused on a section with
as many varying shades as possible.

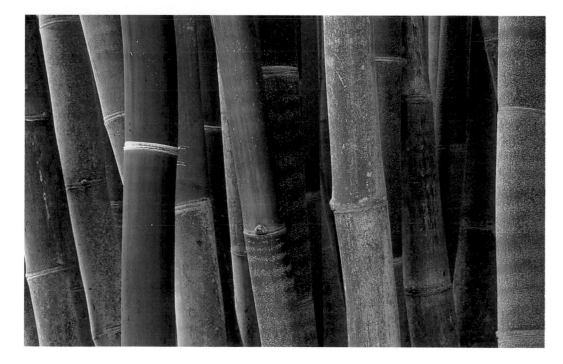

Sunrise, Wild Goose Island, Glacier National Park, Montana
Nikon N8008s, Nikon 80–200mm lens + 1.4X teleconverter, Fuji Velvia
Rod Barbee

Sunrise . . . a peaceful morning . . . one of the most magnificent places in the country. It couldn't get any better. I wanted to isolate the island against the warm light of an early July morning and also keep the background simple. Using a 1.4X teleconverter with my 80–200mm zoom lens enabled me to eliminate the distracting light blue sky.

Granite boulders, Moraine Lake, Banff National Park, Alberta, Canada
Nikon F5, Nikon 28–85mm lens, Kodak E100SW
Mark D. Baker

After making a series of photographs of Moraine Lake with different compositions and foreground elements, I noticed a huge boulder slightly overhanging the lake. Slowly I moved down the slope into position, trying to avoid sliding into the water, and made this shot. The boulder turned out to be the most appropriate foreground for this image.

Pine tree, Acadia National Park, Maine
Nikon N90s, Nikon 80–200mm lens, Fuji Velvia
Tibor Vari

I was hiking up the Dorr Mountain South Ridge Trail in early October when my friend and I stopped to take in the view of Acadia National Park. I noticed this pine tree, with the beautiful twists of its frame, and the fall background. I wanted to frame the tree tightly and blur the background, so I used a medium-telephoto lens.

Next, if you see lots of things to photograph when you come to a scene, take lots of photographs. If you say simply, "Boy, this sure is pretty," and then take a picture of the entire scene, you'll end up with a paragraph (a photograph) that isn't nearly as pretty as you originally thought it was. This is why. When you come to a big scene and marvel at all of it, what you're really doing is marveling at the sum of all of its pretty parts. When you try to take a picture of all of its pretty parts, all the other stuff in-between that isn't really so pretty is also included. You end up with a photograph (a paragraph) with each little pretty part (each phrase) adrift in sea of ugly. Not a pretty picture!

Instead of photographing the whole scene in one image, take lots of pictures of just the things you like. After you say "Boy, this sure is pretty," ask yourself "What exactly is it that I find pretty?" If you say you like the flowers along the stream, shoot just the flowers along the stream. If you say you like the little waterfall, shoot just the little waterfall. If you say you like the interesting tree against the sky, shoot just the interesting tree. All of these photographs together will add up to "Boy, this sure is pretty," but each one individually will be pretty in its own right. Many interesting phrases add up to one interesting paragraph.

I'm not suggesting that you should always shoot tight compositions without context. Context is often a very important part of a photograph. Context provides the viewer with a sense of place, a sense of the familiar. But context and inclusion are quite different. If you want to show a hawk perched in a tree, it is fine to show the tree, at least part of it. If you want to take a picture of a mountain reflected in a lake, it is okay to show enough of the water to identify it as a lake. But it isn't okay to show all the other trees in the forest where the hawk is perched or the mountains to either side of the mountain you liked. Those would be other pictures. If you said you liked the hawk perched in the forest, then you might want to include other trees. And if you said you liked the mountain range reflected in the water, then you would want to include more mountains.

Your decision all depends on how you defined what you liked about a scene, what was your creative vision. Just don't take a photograph of the forest when you wanted just the single tree with the hawk. If you like both compositions, take two pictures.

FINDING A SUBJECT

So far it sounds like you can do all this compositional thinking standing next to your car or on the drive out to your location. Actually, the best time to do this is while you're wandering around looking for something to photograph. I'm not talking about a short amble from your parking spot or your back door; I'm talking about a serious, twenty- to thirty-minute walk. If you are in a hurry while photographing, don't even bother.

When I am in a meadow or a forest, I usually walk in concentric circles looking for either the best angle to photograph my subject from or the absolutely best subject to photograph. If I've parked along a road, I'll walk back and forth along the road. Wherever I am, the longer I take looking for a composition, the better my shot will ultimately be.

Wandering is especially important when I'm doing big, sweeping landscapes. At these times I'm almost always looking for a good foreground for my composition. Interesting foregrounds are easy to find, but they aren't always very appealing. Intriguing and pretty foregrounds that relate to the background and invite the viewer's participation are much harder to find and take much longer to shoot.

While wandering, don't walk through a potential composition if your footsteps are evident. This is especially important if you are on a beach or in a wet meadow. Walk along the edges first, and go into your location only if you are sure you won't be retracing your steps in the near future.

Also, while you're looking for something to photograph or refining your composition, you might want to bring along your camera. Don't attach your tripod to your camera; simply hang your camera around your neck. With your camera off your tripod, you have the freedom to move around and examine every possible angle. With your tripod attached, you'll never examine every angle; most likely, you'll take the photograph with your tripod set as it is.

Textures in sand dunes, Death Valley National Park, California
Fuji G617, Fuji 105mm lens, Fuji Velvia
Craig Clinton Sheumaker

I'd walked for hours since before sunrise over the dunes, but these contrasting textures made me sink to my knees. I wanted an extremely low camera placement to accent the foreground texture, and even though it was New Year's Day, I needed to hide a row of footprints just over the hill.

BELOW
Lone tree in landscape, Chico, California
Nikon FE2, Nikon 85mm lens, Fuji Velvia
Daniel Mohr

I reluctantly passed this composition while traveling from Chico, California, on to San Francisco. I doubted I would find such a shot again, but that afternoon there it was! Without my tripod I braced my elbows and held my breath. Click—a twelve-hour photo!

Once you've found the best subject to photograph or the best angle to photograph from, mark your location and then be sure to memorize the height of your soon-to-be photograph. I usually drop my hat on the ground or hang my coat on a branch to mark my spot. If I walk around but don't mark my location, I have a very hard time finding the spot again after I've retrieved my gear. It is a good idea to mark the location of your gear, too. If you don't mark your various pieces of gear, you might spend more time trying to relocate your camera bag than photographing your subject. Extend your tripod over your gear or bring some bright plastic tape to mark it.

Blood star and green sea anemone
Nikon N8008s, Nikon 105mm macro lens, Fuji Velvia
Rod Barbee

Keeping your footing, keeping your cameras dry, and eliminating distracting reflections offer challenges to tidepool photographers. Polarizers help with reflections, as do people willing to cast a shadow in a strategic location. After positioning my tripod above this scene, I used a focusing slider to move the camera up and down, achieving the image desired.

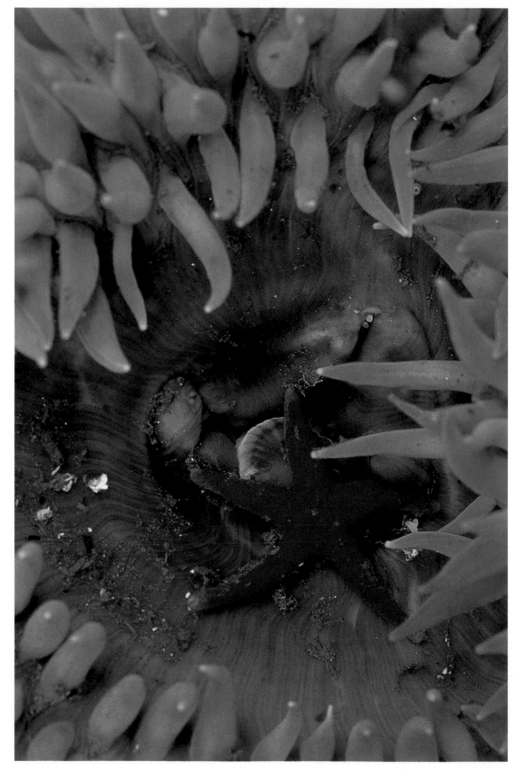

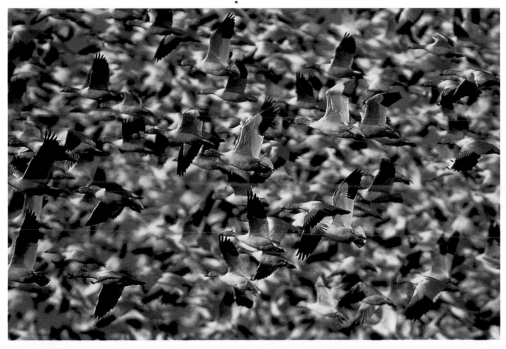

Snow geese, Skagit Valley, Washington
Nikon F4, Nikon 500mm lens + 1.4X teleconverter, Fuji Provia
Terry Wallace

From high in the Arctic tundra, thousands of snow geese migrate to the Skagit Valley to spend the winter. I captured this image by waiting for these beautiful birds to explode into flight.

BELOW
Sunset at Elephant Rock, Prince Edward Island, Canada
Nikon F3, Nikon 28mm lens, Fuji Velvia
Oliver Bolch

When I was driving to Elephant Rock, I noticed a narrow gap between the sky and the sea where the sun would come out. I found a good view on the edge of the red cliffs. I had less than two minutes to capture the magic.

Black-crowned night heron, Mt. Pleasant, South Carolina
Nikon F4, Nikon 600mm lens, Fuji Velvia
Lisa Von Moll

Risking my life with alligators sunning themselves nearby, I photographed this black-crowned night heron on a branch in a pond where numerous herons were nesting. Going unnoticed behind a tree, I made my shot with a 600mm lens. The duckweed covering the pond provided an out-of-focus green background.

White ibis, Cypress Gardens, Florida
Nikon F5, Nikon 500mm lens, Kodak E100SW
Wayne Bennett

I was photographing ospreys near a lake in central Florida when I turned around and saw this ibis on the shore of the lake. When the light broke through the trees and illuminated the bird's face, producing a catchlight in the eye, I fired away.

OPPOSITE
Backlit snowy egret, St. Augustine, Florida
Nikon N90s, Nikon 500mm macro lens, Fuji Velvia
Judy Norton

Having been to this rookery before and knowing the birds were extremely accessible, I chose my 500mm macro lens—not for the distance the lens provided, but so that I wouldn't intimidate the birds or restrict their wonderful behavior by being too close.

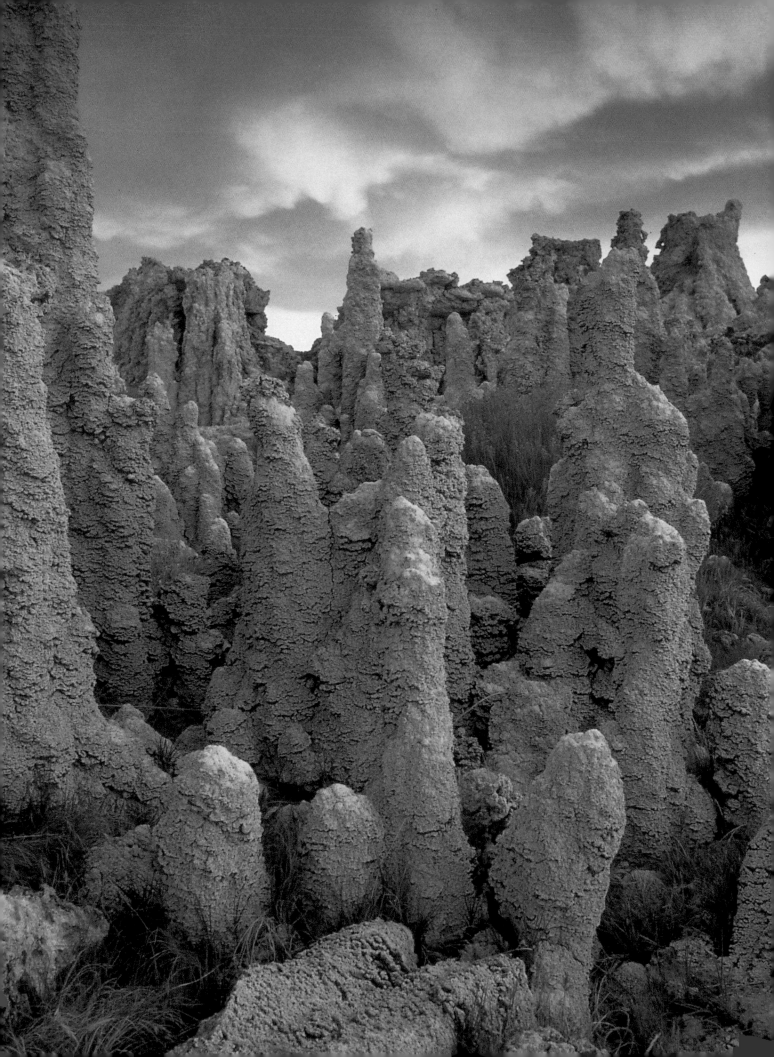

Light edge on leaf, Ding Darling National Wildlife Refuge, Sanibel, Florida
Canon Elan, Canon 100–300mm lens + extension, Kodak Lumiere
Stan Grigiski

Walking around the area, I noticed the light shining through various leaves. I used my extension tube for extra magnification, as well as to keep a safe distance between the lens and subject so as not to damage the plant. I was also careful to find a dark background within the shade to eliminate any light spot distractions.

OPPOSITE PAGE
Tufas at sunset, Mono Lake, California
Nikon FE2, Tokina 24–45mm lens, Kodachrome 64
John M. Juston

When I shoot in locations that are frequently photographed, such as Mono Lake, the challenge is to walk away with a picture that shows my individuality and vision. Here I sought out a composition facing away from the lake to isolate the strangeness of the tufa formations against the sunset sky. This was one of those rare, beautiful instances when I knew, then and there, that my creativity had converged with the elements to produce a lasting image.

TOP
Palmetto palm, Sanibel Island, Florida
Olympus OM-2, Novoflex 135mm lens, Kodachrome 25
Gisela Polking

I took this image because I was so intrigued by the strong design of the palmetto palm.

BOTTOM
Longleaf pine needles, Francis Marion National Forest, South Carolina
Nikon FA, Nikon 70-210mm lens + Nikon 5T closeup lens, Kodachrome 64
William R. Gates

Because of obstructions around this grass-stage longleaf pine, I used a 70-210mm lens with a 5T supplementary lens instead of a 55mm macro lens. The extra working distance permitted me to avoid the obstructions and station my tripod-mounted camera so the film plane was perfectly parallel to the subject.

DECIDING WHEN TO PHOTOGRAPH

Once you've decided what it is you want to capture on film, you have to consider four components of the photograph: light, subject, background, and conditions. Each of these must be right and each must be at its best for your photograph to be its best. If the subject couldn't be better, the background is just right, and the conditions are perfect but the light is dull, the resulting photograph will still be dull. And if the subject is great, the conditions are unbelievable, and the light is sweet but the background is distracting, the photograph will still be a failure.

The best light really depends on your photographic intentions and your choice of subject. I prefer soft, delicate light for soft, delicate flowers; warm sidelighting for landscapes; slightly diffused light for wildlife; and even, rainy light for forests. If I try to take a picture of a forest in direct, hard sunlight, the photograph will be a throw away—no matter how beautiful the forest is or how much I try to convince myself otherwise.

I often get so involved in the process of taking a picture that I forget to notice the quality of the subject. Is it flawed, misshapen, dirty, or past its prime? Are there chew marks on the flower petals or a tag in the animal's ear? I once shot three rolls of film of a dirt road winding through a beautiful, foggy redwood forest, and it wasn't until I looked at the film on my light table that I noticed a very obvious beer can in the ditch along the road. Magnificent light, perfect conditions, a stunning background but the subject had one quite visible flaw that I unfortunately didn't notice until it was too late. Every shot I took ended up in the trash can.

The background of a photograph will often determine the overall impact of the image. If the background draws

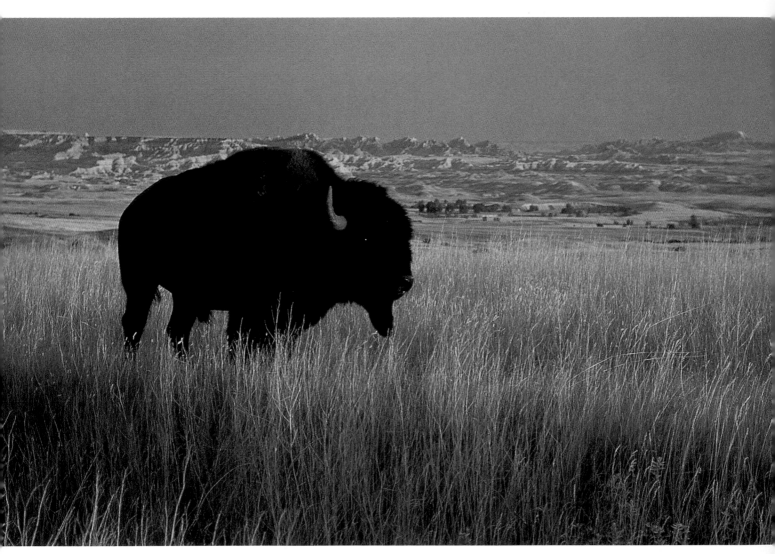

Bison, Badlands National Park, South Dakota
Nikon F4, Nikon 35–105mm lens, Fuji Sensia
Rodney Evans

Although this bison is the main subject in the photograph, the late-evening light and the approaching storm add visual drama to the scene. With a short telephoto lens I was able to capture this magnificent animal in its prairie habitat.

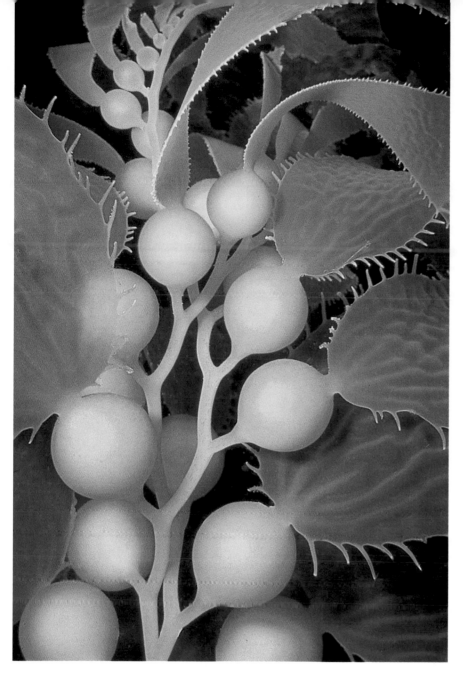

Giant kelp plant detail, Santa Catalina Island, Southern California
Nikonos V underwater camera, Nikon 35mm lens + extension, flash, Kodak Ektachrome 100 Professional
Ken Howard

With the lens aperture set to f/22, the effective aperture due to the extension tube was f/29, which provided a depth of field of about 3/4 inch. To produce adequate lighting, I set the strobe on full manual power and handheld it very close to the kelp plant.

attention away from the subject, the picture will suffer. Bright spots, distracting lines, and uncomplementary colors are all common suspects in the lineup of photo saboteurs. When you look at the flower photographs in this book, notice how simple and complementary the backgrounds are. The appropriate background enables the beauty of the subject to fully show. To get the best background, faithfully use the depth-of-field preview button on your camera.

The human mind is a funny thing. The longer I spend waiting for the wind to die down so I can take a picture, the more tolerant I am of how strongly the wind is actually blowing. If I wait for five minutes, the flower has to be absolutely still for me to take its picture. If I wait for twenty minutes, the flower can be moving all over the place but in my mind I've managed to convince myself that the flower isn't really moving that much. Unfortunately, the time and effort invested in a photograph don't offset bad photo-

graphic conditions. If it is too windy, too rainy, or too dry, or if you are in too much of a hurry to wait until conditions improve, your photograph won't work—no matter how much you rationalize on the spot.

So what do you do when presented with a less-than-optimal situation? You can try to alter the light with a diffuser or with fill flash. You can also try a different composition that incorporates the wind movement. Another option is to try to frame the picture differently in order to cut out the unfortunate flaw. You can also try to shade the bright background to eliminate the distracting light spots. Never damage or destroy a subject just to move it to a prettier location, though. No photograph is that important. You can come back at a better time. Sometimes, however, that isn't an option. Sometimes the best you can do is simply to enjoy where you are and not take a picture. It could be worse—you could be back in the office!

Lava flowing into ocean, Hawaii Volcanoes National Park, Hawaii
Pentax LX, Pentax 35mm lens, Fuji Velvia

Allen Karsh

To get this image I hiked about 2 miles to where the lava from Kilauea was flowing into the ocean in Hawaii Volcanoes National Park. I waited about forty minutes after sunset and used an exposure of several seconds so the fiery, explosive forces of the lava would best be recorded on film.

Lightning bolts, Steptoe Butte, Washington
Canon EOS-In, Canon 35–350mm lens, Fuji Velvia

Alan Caddey

The sun had just set near Steptoe Butte in the Palouse Country of eastern Washington. I quickly composed with a 135mm setting on my lens, to show both landscape detail and the colorful thunderous sky. Two of my 30-second exposures captured lightning striking the Butte. An exciting evening.

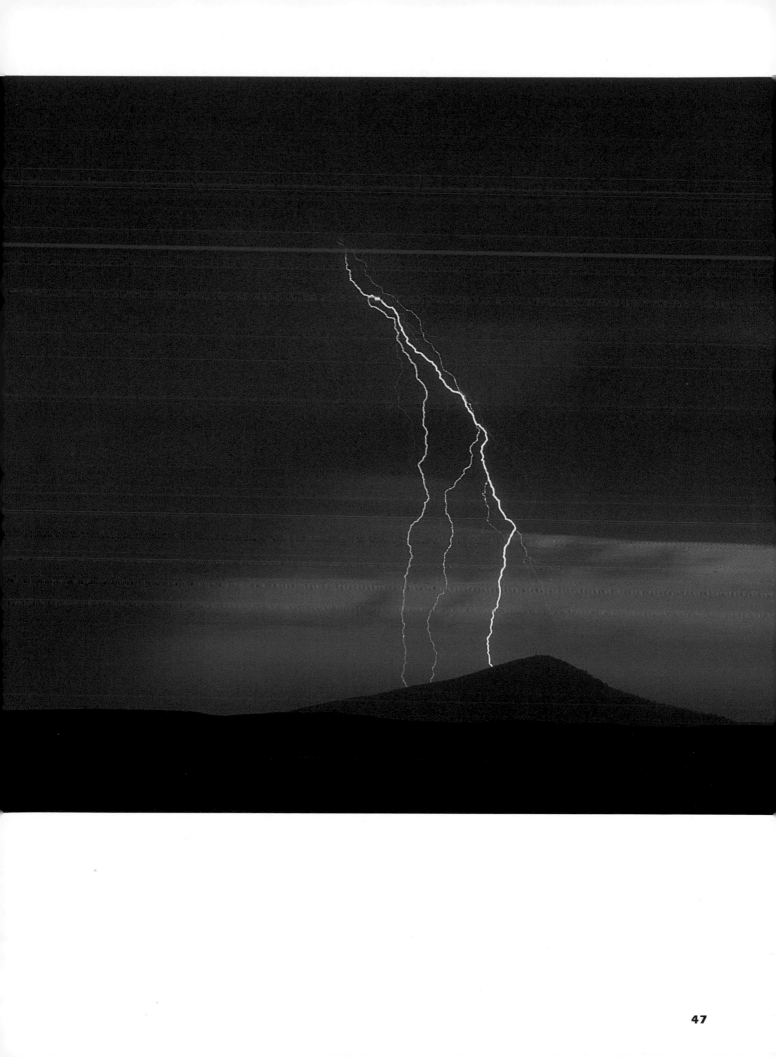

Wayne Lynch
Approaches to Wildlife Photography

Grand, sweeping landscapes can be inspiring and fun to photograph at times, and there is no doubt that wildflowers please the crowds and editors with their delicate color, texture, and tone. Yet as a nature photographer, I quickly tire of these subjects, which often leave me cold. The reason: they literally have no heart. To be excited about my photography, as I often am and like to be, I need a subject with a beating heart. Then I'm a happy guy. I admit it. I'm a critter junkie, but my addiction to wildlife and animal behavior has given me a lifetime of excitement and intellectual stimulation. Humans share this planet with at least ten million other fascinating creatures, so there is no shortage of subjects to explore and discover, and I guarantee the journey will be filled with wonder and surprises.

Photographers, both professionals and amateurs alike, often complain that every animal and bird has been photographed, and that there is nothing left to work. Well, as much I would like them to believe this so they'll sell their equipment and do something else, I couldn't disagree more. In fact, it is just the opposite. Spend a few days in a blind, and you'll see that practically nothing has been worked well. This past spring I spent two months focusing on waterfowl and other birds in the wetlands of Alberta, and I came away amazed at the rich repertoire of behavior I'd witnessed, as well as how little of it I was able to capture on film. It inspired and challenged me, and the opportunities seemed endless. All of this was possible because of one piece of equipment, the photo blind—the wildlife photographer's most important tool.

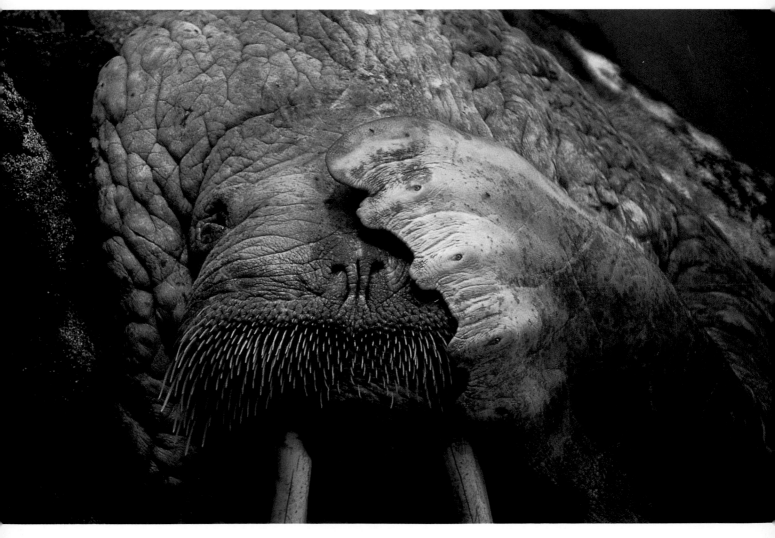

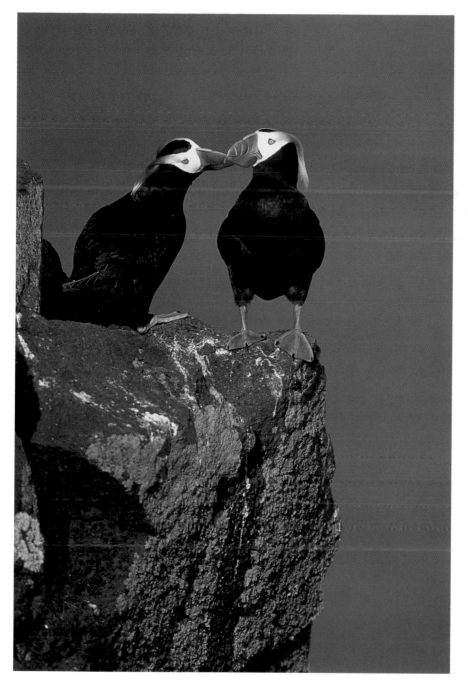

Tufted puffins
Canon EOS-In, Canon 400mm lens + 1.4X
teleconverter, Fuji Velvia
J. Scott Schrader

I photographed this image on a visit to St.
Paul Island in the Pribilofs. I used my long lens
with a teleconverter to isolate these birds
from the hundreds of others that were on the
cliffs at the time.

Walrus, Round Island, Walrus Islands State Game Sanctuary, Bristol Bay, Alaska
Minolta 700si, Minolta 500mm mirror lens, Fuji Velvia
James D. Ronan, Jr.

This photograph was made at midnight on Round Island in
late June, just as the sun was dipping below the horizon. The
walrus had hauled itself out on a rock outcropping that left it
more than 15 feet above the ocean when the tide went out.
I spent a couple of hours moving into position so that I
wouldn't disturb the walrus in to a hasty retreat and
potentially cause him harm from a fall.

Breeching humpback whale, Alaska
Canon A2, Canon 70–200mm F2.8 lens, Fuji Velvia
Cathy Allinder

For this photograph I used my fast zoom lens. A fast lens is required to capture the acrobatic activity of the humpback whales in southeast Alaska.

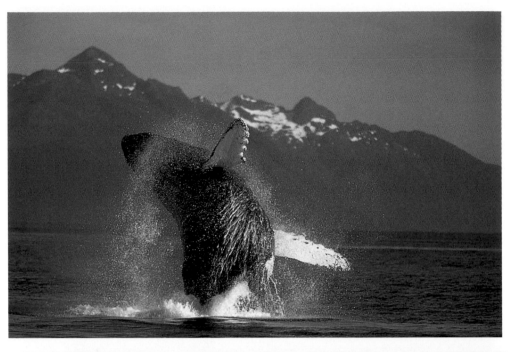

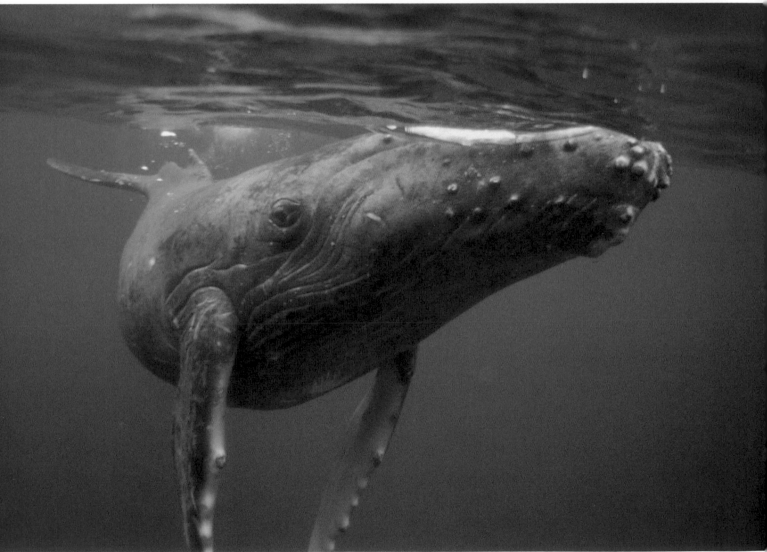

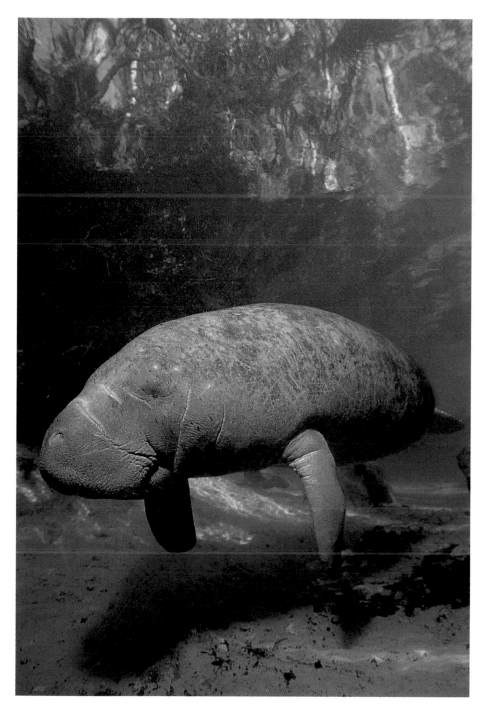

Manatee, Crystal River, Florida
Nikonos V underwater camera, Nikon 15mm lens, flash, Kodak Ektachrome 100 Professional
Ken Howard

The Kings Bay area of Crystal River, Florida, attracts many snorkelers to see manatees, which can turn the water quite murky. I positioned myself in a channel between one of the natural springs and the bay it flows into. The slight current continually cleansed the water, and getting close to the subject with a wide-angle lens also helped optimize visibility.

Humpback whale, Kona, Hawaii
Nikon RS underwater camera, Nikon RS 50mm lens, Fuji Provia
Steve W. K. Lu

While snorkeling, I spotted this calf with his parents resting motionless at a depth of 80 feet. The calf glanced at me curiously, then quietly sneaked away from his parents' protection to approach me at the surface. He then performed a series of acrobatic gestures—splashing, rolling, darting, and breeching—before heading straight toward me. I took this shot the moment before he made a U-turn to playfully slap me with his tail, after which he slowly returned to his resting parents. The whole extravaganza lasted less than a minute.

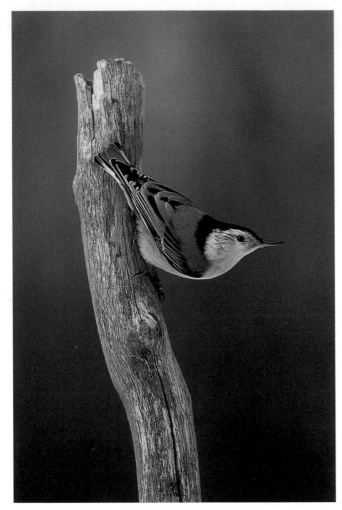

White-breasted nuthatch, Kingston, Tennessee
Canon T90, Canon 400mm lens, Fujichrome 100
Ron McConathy

I captured this white-breasted nuthatch in a classic head-down posture from my homemade blind. I'd positioned the blind near the edge of the woods to provide a simple, out-of-focus background.

BECOMING A VOYEUR

A blind, which is also called a hide by the British, is anything that conceals you from the wildlife you want to photograph. The best blind is one that blends with the environment; you can use chicken wire woven with natural materials such as shrubbery, tree branches, grasses, cattails, and bulrushes. This kind of blind certainly works well, but it takes a lot of effort and most wildlife will accept much less. For birds, I sometimes use the discarded cardboard boxes that washing machines and refrigerators are shipped in. The boxes are a good choice for a number of reasons. You can usually get them for free at any appliance store, they withstand the weather for several months, they don't flap in the wind, and they are unattractive to thieves.

Small pup tents also work well as blinds, but photographing from them can be awkward. The advantage to a tent is that you can sleep in it overnight and be in position when the first rays of daylight crack the horizon. For several years in a row, I erected a small backpack tent on the spring dancing grounds of a group of sharp-tailed grouse. At night I fell asleep to the cooing of male birds, and when dawn arrived at 5:30 A.M. I was ready to shoot.

Designer camo blinds are commercially available from a number of outdoor photo suppliers. These blinds are portable, weigh just a few pounds, are supported by collapsible Fiberglas poles, have multiple ports for shooting, and are specifically designed for wildlife photography. You can also make your own blind, and although it isn't that much cheaper to do so, at least the blind will be to your own specifications. If you shoot with your spouse, as I frequently do, you might want to build a blind-for-two where there is room for a big cooler and a port-a-potty.

The type of blind I use most often is a "pocket blind"; in fact, I bring one with me everywhere. It has no poles, weighs less than a pound, and is basically just a sack that you throw over yourself and your camera to break up your outline. Songbirds quickly accept a pocket blind, and I've even had unsuspecting sparrows perch on my head. The type of blind you eventually use is limited only by your imagination. In the early 1900s, British photographers Richard and Cherry Kearton hid inside the mounted skin of a cow. Another tenacious photographer in South America dug a pit on the beach and covered himself with stones to photograph wary Andean condors feeding on a rotting sea lion carcass.

Bald eagle on salmon, Coweeman River, Washington
Nikon F4, Nikon 600mm lens, Kodak E100SW
Steve Carlisle

I shot this scene from a blind on the Coweeman River near my home. The eagle is feeding on a spawned-out Coho salmon. This river hosts a run of these salmon each year in early October. I shot my first pictures on the seventh day of waiting in the blind for two hours every morning.

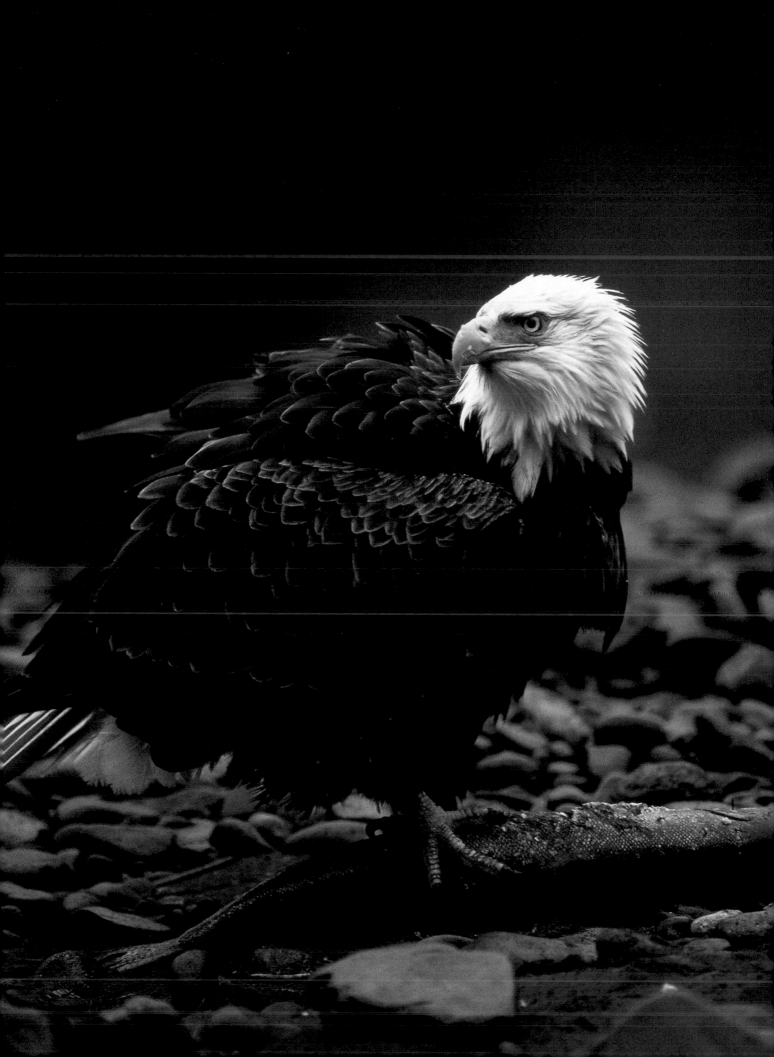

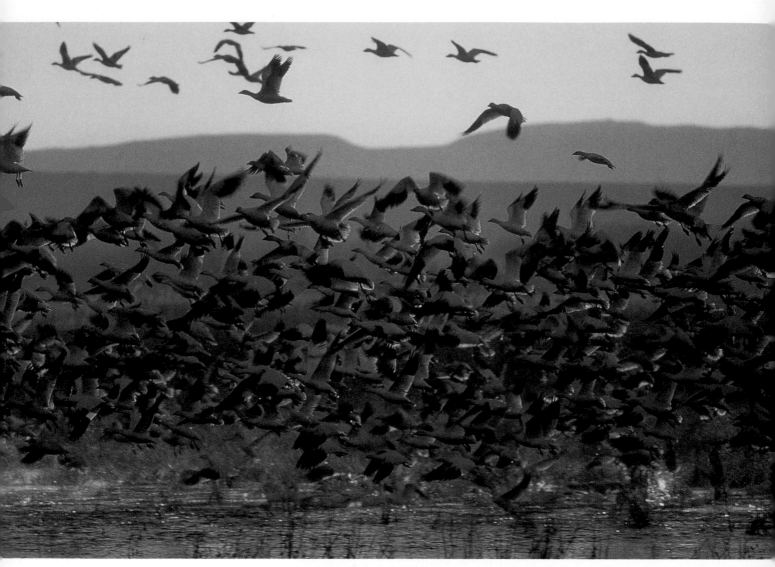

Snow geese at sunrise, Bosque del Apache National Wildlife Refuge, New Mexico
Canon EOS-In, Canon 400mm lens, Fuji Sensia
Gregor Busching

At Bosque del Apache, thousands of snow geese sometimes gather on one spot for the night. As the sun rises they suddenly lift off—with enormous honking and quacking—to reach their feeding grounds. I chose a camera position that was good for backlighting, so this huge flock would be spotlit with glitters of light.

RIGHT
Wood duck, Coweeman River, Washington
Nikon F4, Nikon 600mm lens, Kodak E100SW
Steve Carlisle

I photographed this wood duck at a small pond near my home one April while working from a blind at daybreak. Several pairs of wood ducks visit this pond each spring in the mating season and nest nearby.

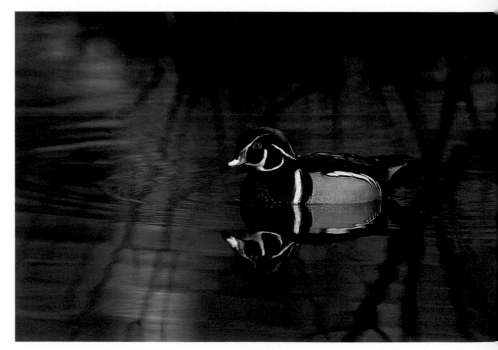

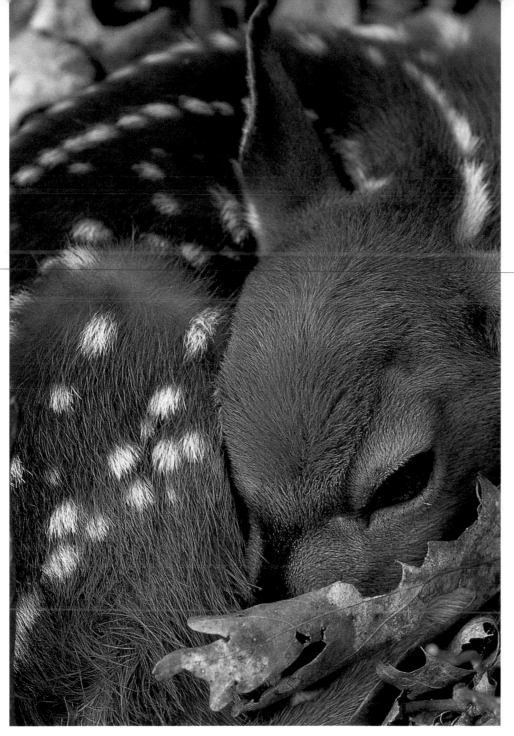

White-tailed deer fawn,
Beaver Creek Valley State
Park, Minnesota

William Petersen

WHERE TO HIDE YOUR HIDE

Once you have a blind, the next trick is to find a good location. At first you might need to observe your subject from a distance with binoculars for a few hours or a few days. Within the home range of most wild animals are areas they use for loafing, grooming, sleeping, feeding, drinking, mating, and raising young. They often have regular travel routes and escape routes. Any of these areas might provide photo opportunities, but blinds work especially well in a few locations.

Feeding Areas

At low tide you'll find that the exposed mudflats and intertidal zones of many coastal areas attract hungry shorebirds, gulls, and crows. These same feeding areas are especially productive for waterfowl and shorebirds during both the spring and autumn when the birds are fattening themselves up for their annual migration. The shoreline of any lake or river might also yield a procession of wildlife subjects for you to photograph.

Salmon-spawning streams are another popular site for wildlife photography. I spent nine years working on several books about northern bears, and the hundreds of hours I spent staked out at salmon streams were always rewarding. In addition to the burly bruins I also photographed other wild creatures, such as river otters, ducks, eagles, and many kinds of songbirds.

Mountain goat female and kid, Mt. Evans, Colorado
Nikon FM2, Nikon 300mm lens + 1.4X teleconverter, Fuji Velvia
Ken Archer

I found myself precariously close to an extremely steep dropoff in order to obtain the angle I needed. I wanted to include a portion of the sky to provide a contrast between the goats, snow, and rock face. My 300mm lens alone didn't provide the magnification I desired, so I added my 1.4X teleconverter. This image was the last frame on my roll of film, which seems to happen to me quite frequently in extraordinary situations.

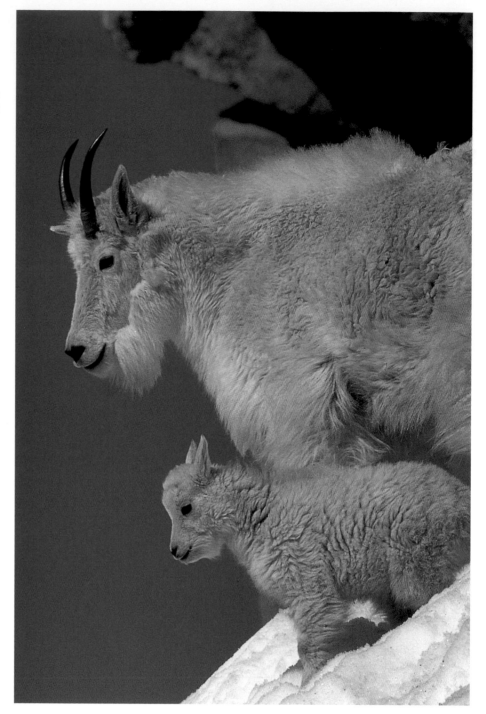

RIGHT
Grizzly bear sow and cubs, Middle Creek, Shoshone National Forest, Cody, Wyoming
Nikon N8008s, Nikon 400mm lens, Lumiere X
Leon Jensen

I was looking for bears one morning near the east entrance to Yellowstone National Park when I found this sow and cub in Shoshone National Forest, one of the five forests that surround the park. I watched the bears descend a hillside and drop into Middle Creek. As they crossed the stream I photographed them with my 400mm lens.

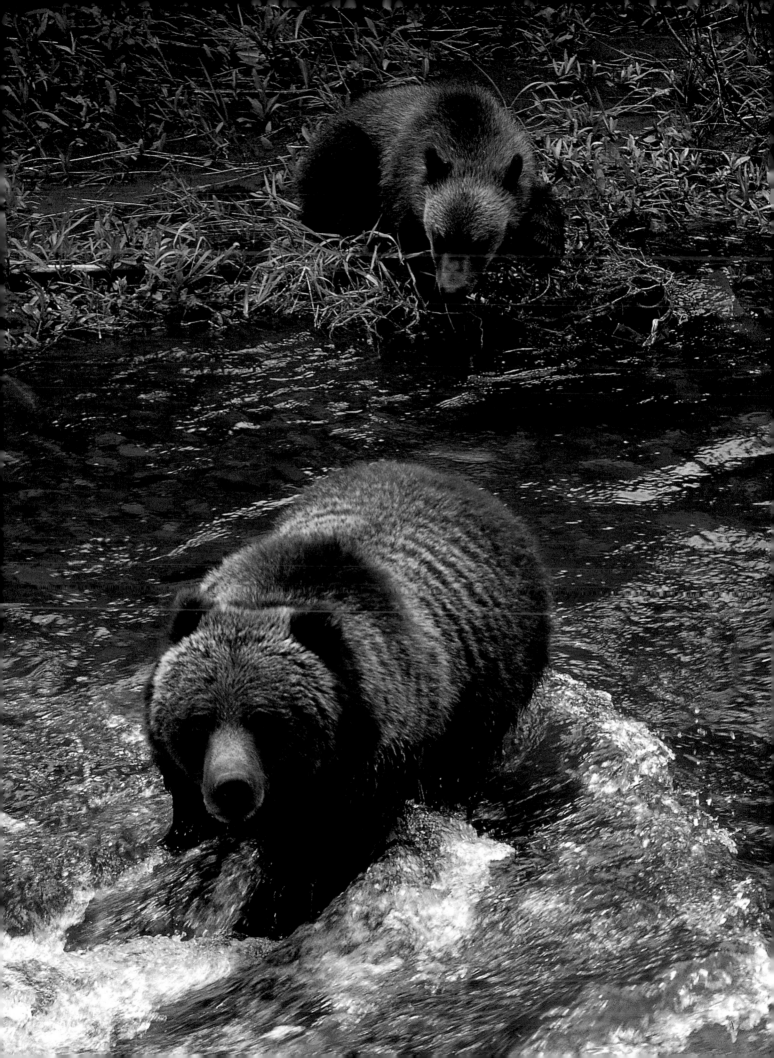

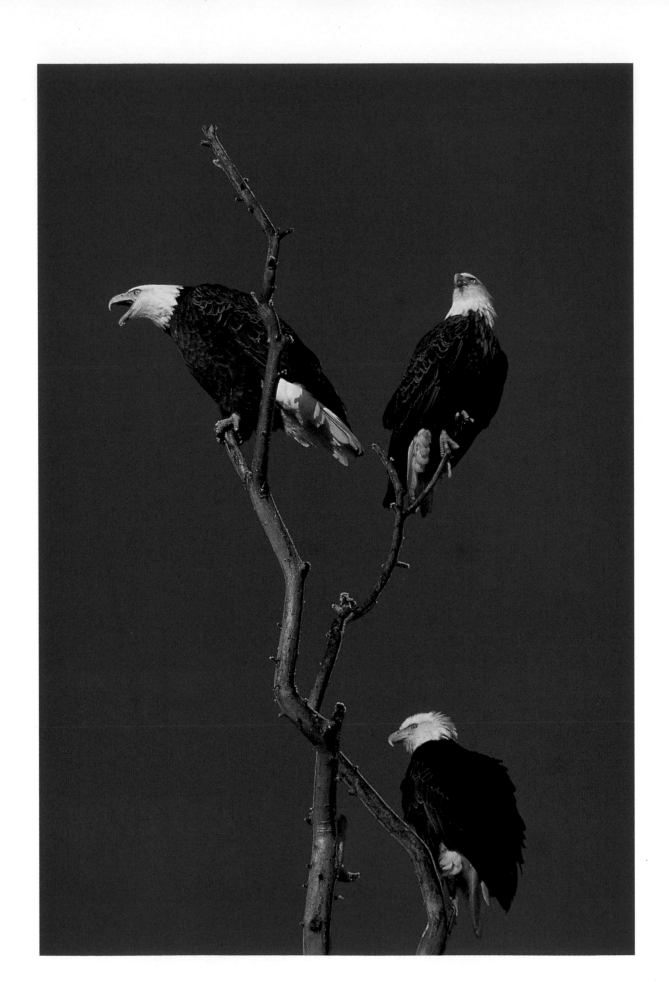

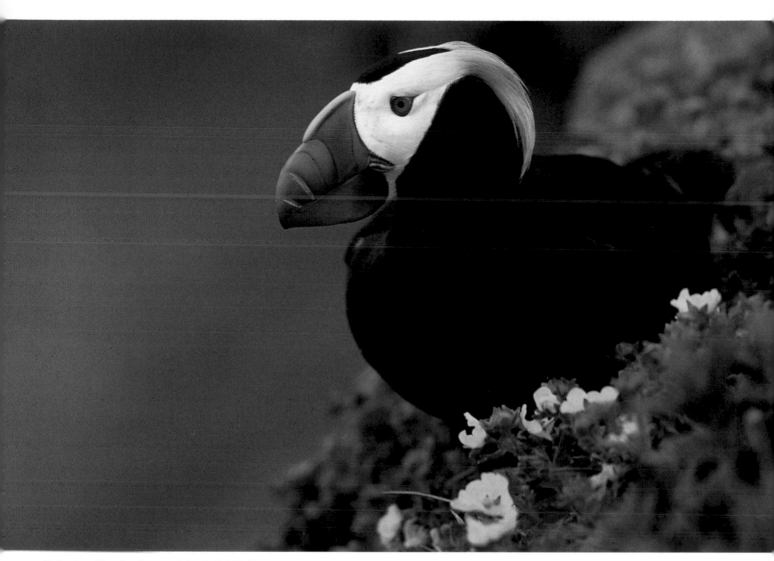

Tufted puffin, St. George Island, Pribilof Islands
Canon EOS-1n, Canon 500mm lens
Robert M. Griffith

Patience and windproof, warm clothing are two prerequisites for photographing nesting sea birds on St. George Island in the Bering Sea. I was able to isolate this tufted puffin by using a 500mm lens as I worked along the tops of the cliffs.

LEFT
Bald eagles in tree, Lower Klamath Wildlife Refuge, California
Nikon F4, Nikon 300mm lens, Fuji Provia
John Cang

After several mornings in a cold, cramped blind, I was rewarded with eagles against a blue sky. Working with a 500mm lens, I determined exposure with spot-meter readings of head, body, and sky. I switched to my 300mm lens for this group shot.

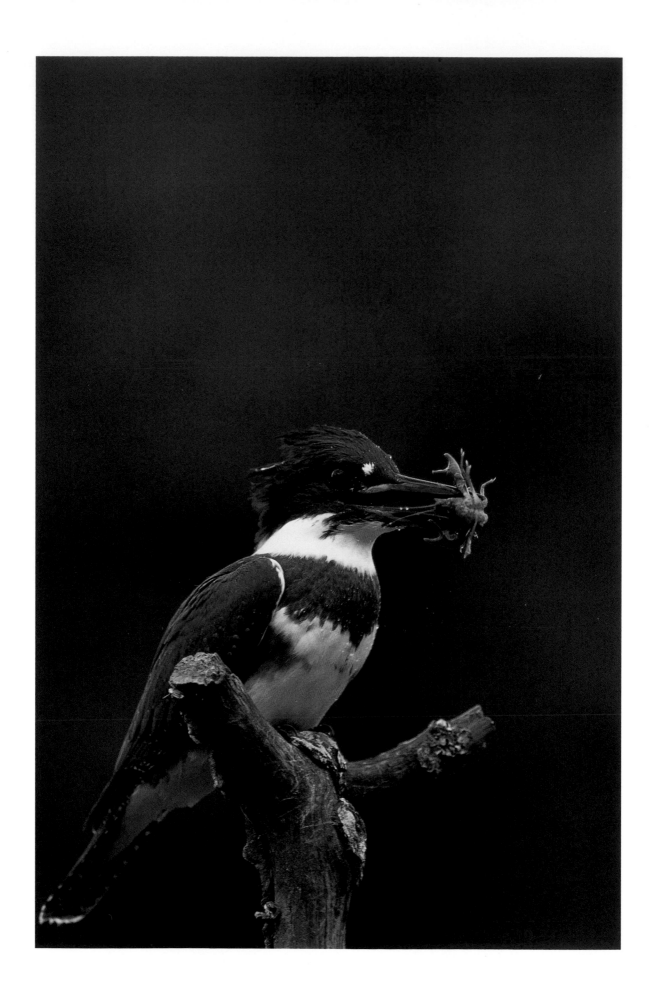

Nests

Everyone knows that bird nests provide good opportunities for photographs, but shooting at a nest site *always* carries a serious risk for the bird. Early in the nesting season, the presence of your blind might disturb a bird profoundly enough to make it desert its nest. Later in the nesting cycle, a blind might keep nervous adult birds away from the nest long enough to threaten the survival of their offspring. Eggs and young hatchlings, for example, are susceptible to both overheating and chilling, and might need to be continually brooded by their parents.

In general large birds are more vulnerable to nest desertion and disruption than small birds are. Birds of prey, such as eagles, hawks, and falcons, are some of the most easily frightened and require the greatest care. Don't love your subject to death.

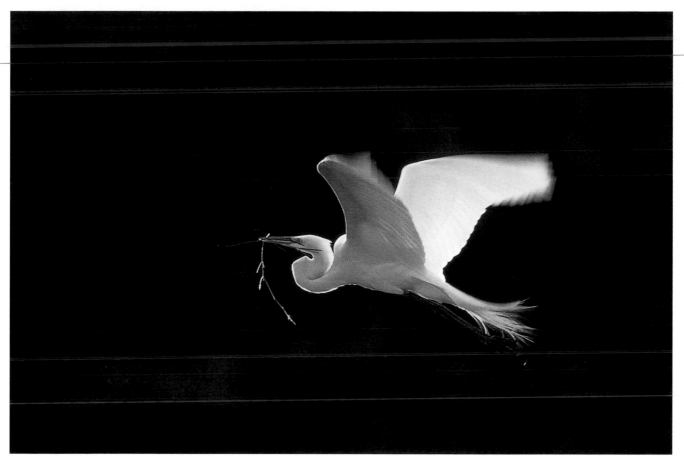

Great egret in flight, Venice, Florida
Nikon F5, Nikon 500mm lens, Fuji Sensia

John Cang

The evening backlight coming through the egret's flight feathers provided a warm, luminous effect, which the background of dark foliage accentuated. I experimented with slow shutter speeds to blur the bird's wingtips and convey a sense of motion.

LEFT
Belted kingfisher with crayfish, Coweeman River, Washington
Nikon F5, Nikon 600mm lens, Kodak Lumiere

Steve Carlisle

I took this photograph from a blind near a perch on the Coweeman River near my home. After I spent many mornings in the blind, the female kingfisher rewarded me by posing proudly with her best catch in weeks (this shot was mine.)

Egret feeding two young, Venice, Florida
Nikon F4, Nikon 500mm F4 lens + 2X teleconverter, Fuji Velvia

Mervyn Rees

I took this photograph at the Venice rookery in southwest Florida, where many nesting birds—and almost as many photographers—are in springtime. The problem is isolating a single family and, preferably with a sky background, waiting for an interactive moment. I was able to capture this combination by using a Nikon 2X teleconverter on my 500mm lens.

OPPOSITE PAGE
Nesting swan, Cape May, New Jersey
Canon A2, Sigma 400mm lens, Fuji Velvia

Maryellen Cole

I used my 400mm lens to capture this nesting swan in the glow of the afternoon light in Cape May. By climbing on a nearby gazebo deck to shoot, I was able to create a portrait of the swan in her natural environment.

BELOW
Common loons
Canon EOS-ln, Canon 300mm lens, Fuji Provia

Gregory M. Nelson

This image combines a bit of luck with a great deal of patience. By using a 300mm lens and having the subjects parallel to the film plane, I was able to make a photograph that captures several unique behaviors of this magnificent species. Here, one loon is feeding a minnow to a one-week-old chick riding on another adult's back.

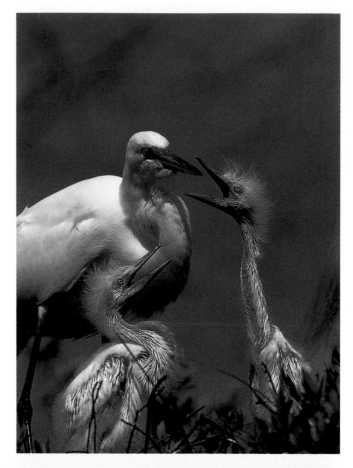

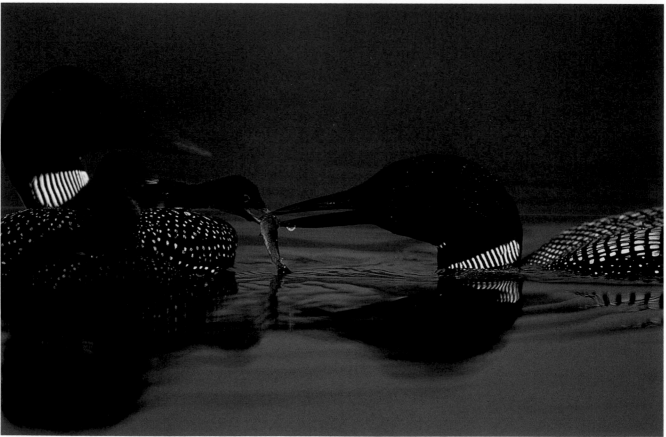

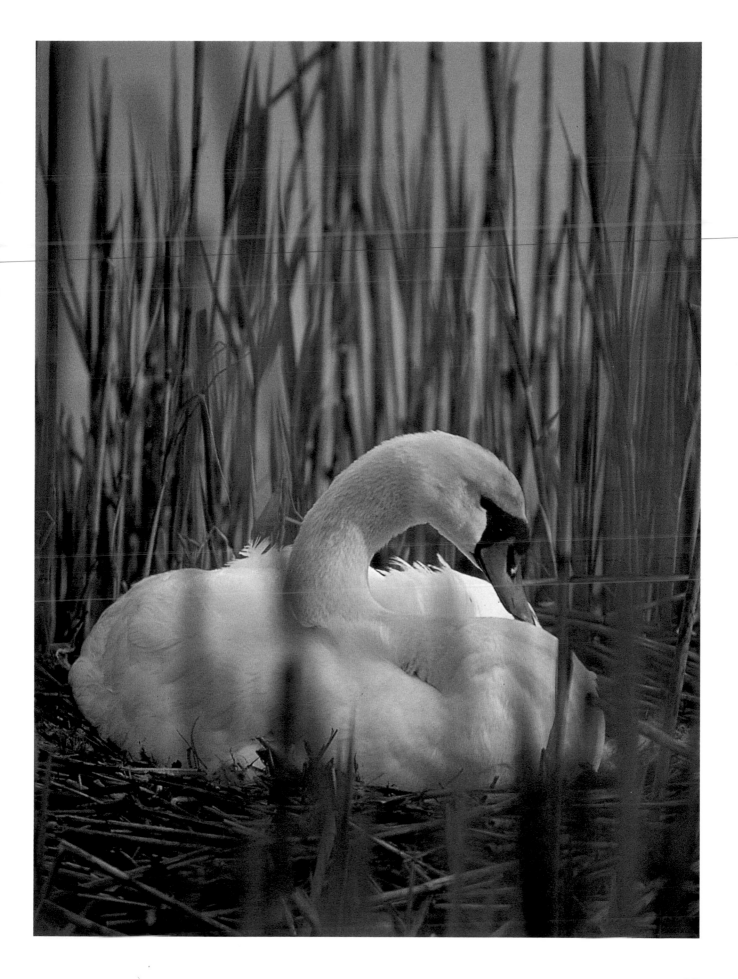

Dens and Burrows

Many small mammals that live in burrows readily accept a blind nearby. Woodchucks, ground squirrels, and marmots are particularly easy to work. Blinds are also effective with muskrats and beavers. Burrow-dwelling predators, such as weasels and foxes, are often more wary than rodents and require more time and care so that they aren't pressured into abandoning their dens. With careful planning, I've used blinds successfully to photograph coyotes, red foxes, swift foxes, arctic foxes, and badgers at their dens.

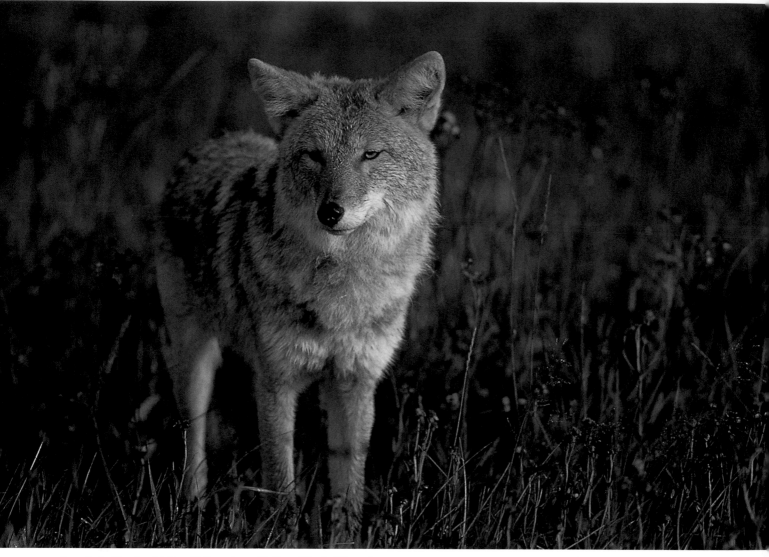

Coyote in Hayden Valley, Yellowstone National Park, Wyoming
Nikon F4, Nikon 300mm lens, Fuji Velvia
Calvin Rone

I photographed this coyote three days in a row. At times he got so close to me that I could have petted him, making it very difficult to work with my 300mm lens.

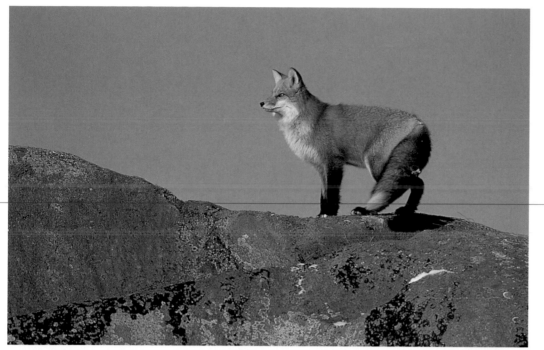

Red fox, Churchill, Manitoba
Canon EOS-In, Canon 500mm lens

Robert M. Griffith

The sun was close to the horizon near Churchill when this beautiful red fox awoke from a nap and trotted up on a rock covered with lichens matching his color. Using my 500mm lens, I got off several shots before the fox disappeared.

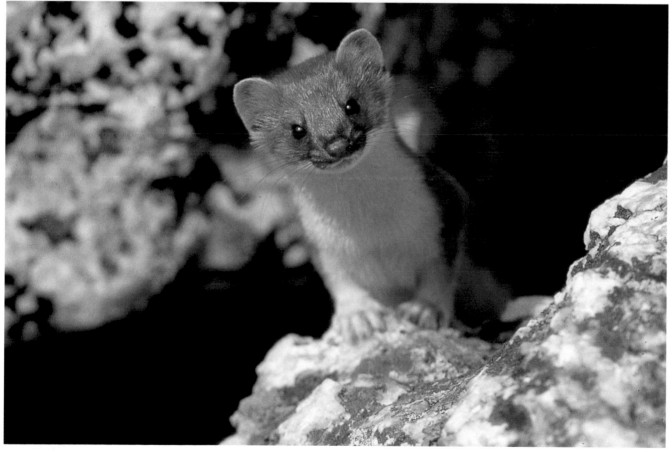

Short-tailed weasel in rocks, Rocky Mountain National Park, Colorado
Nikon FM2, Nikon 300mm lens + 1.4X teleconverter, Kodak E100SW

Ken Archer

Hiking along the Milner Pass trail in Rocky Mountain National Park, I happened upon this weasel, which was hunting among scattered rock formations. I quickly set up my camera near a promising-looking formation. The weasel's sudden appearance caused me to miss the first shot. Luckily the curious little fellow returned a moment later for a second look, and I was able to shoot several images.

MOVING IN

You can set up a blind two ways: all at once or in stages. The choice depends upon the animal and how it behaves. Most animals are very familiar with their home range and everything in it, so they might be disturbed by the sudden appearance of a blind in their neighborhood. If you are in doubt whether the presence of a photo blind will adversely affect an animal, introduce the blind gradually, erecting it over seven to ten days. Another option is to set it up at a distance and slowly move it closer over the same span of time. Watch closely to see that your subjects accept each new change. For example, if a bird on a nest is disturbed by your most recent change and fails to return in a reasonable amount of time, you should move the blind back and slow down your introduction schedule.

Many types of birds, in particular shorebirds and songbirds, accept a blind almost immediately. Any birds that use an area transiently, such as birds in migration, also aren't usually disturbed by the sudden introduction of a blind. Grouse, one of my favorite photographic subjects, is one group of birds that is very tolerant of blinds. Several years ago I erected a blind just 16 feet from the drumming log of a ruffed grouse. After I set up the blind and crawled inside, the grouse was back drumming on the log within fifteen minutes.

Once your blind is in its final position, it is a good idea to go inside and scan the image area with the different lenses you plan to use. Check the background for dead leaves, twigs, and clumps of dried grass that might show up in your photographs as distracting highlights. Remove these

Red-shouldered hawk, Foothills Raptor Center, Tennessee
Nikon 90s, Nikon 400mm lens + 1.4X teleconverter, Kodak Lumiere
Edmund W. Stawick

I photographed this hawk at a rehabilitation center in Tennessee. I wanted a tight portrait of the bird, so I added a teleconverter to my lens. The resulting longer focal length provided another advantage: narrowing the background coverage, thereby eliminating some distracting elements.

only if they aren't necessary for the concealment or safety of the animal. Distracting branches can sometimes be temporarily tied back from a nest with black thread or fishing line and then released when you're finished shooting.

I discovered another way to lessen the impact of annoying highlights in the background when I photographed a black tern incubating its eggs on a floating mat of soggy marsh vegetation. A wall of old dried cattails behind the nest showed up in my viewfinder as unattractive bright highlights. But because the cattails reduced wave action near the nest and protected it from being swamped, I didn't want to remove them. The solution was to leave the cattails where they were, and instead spray them with dark green paint so that they were much less obvious in the photograph.

THE VALUE OF A BLIND

Using a blind offers a number of obvious benefits. It gives you greater control over the distance between your camera and your subject, enabling you to choose different lenses for different compositions and perspectives. By controlling the position of your blind, you can also control how the light falls on the subject, whether from the front, side, or back. The most important benefit of a blind, however, is that it enables an animal or bird to relax and act more naturally, providing you with a better chance to witness and photograph unique behavior, which in turn is likely to yield a more interesting and original photograph.

COMING AND GOING

Unless you plan to live inside your blind as one filmmaker did for five days while photographing grizzlies in the Canadian Rockies, you'll need to come and go. It is always best to enter a blind when doing so will least disturb your subject, and one of the best times to do this is under the cover of darkness. As a result, I often try to enter my blinds before sunrise. If I'm entering a blind in broad daylight, I might ask a friend to escort me to the blind and then leave the area once I'm safely hidden inside. Most animals can't count, and as long as someone leaves the area they're fooled and believe the danger has left. I've used this trick repeatedly on nesting owls, hawks, loons, and grebes. Naturally this ploy works best with birds that have a poor sense of smell. Keen-nosed mammals aren't so easily fooled since they can readily detect your scent inside the blind.

When you first crawl into a blind, set up your equipment as quickly as possible. Unzip any zippers to avoid making noise later when your subject is near. Anytime you work in a blind, it is a good idea to wear clothing made of soft fabrics that don't rustle. That way, when you're moving around reaching for lenses and film, your clothing won't betray your presence and frighten your subject. Goretex clothing is especially noisy, and you should avoid garments with Velcro fasteners at all costs.

I believe in lots of creature comforts when I am inside my blind. I sit on a comfortable aluminum garden chair. Sitting on the ground or squatting on a tiny camp stool

American kestrel, Duluth, Minnesota
Canon A2, Canon 300mm lens + 1.4X teleconverter, Fuji Sensia
Dudley Edmondson

By using a long focal length, I was able to blur the background into a pleasing collage of green and yellow. This accented the kestrel's copper and blue tones.

numbs my derriere and makes my back ache. Anything that causes discomfort will reduce your patience, reduce the length of time you can endure inside a blind, and, ultimately, reduce the number of photographs you get. I always bring along snacks and something to read. Many idle hours can separate moments of action, and I find reading to be the best way for me to pass the time. I usually select reading material that relates to the animal or bird I'm trying to photograph so that I can gain some added insight while I'm waiting for something to happen. Some photographers claim they would never read while they are in a blind, and they try to remain continually alert and poised for action. Otherwise, they argue, they might miss something. Of course, they are right, and it all depends on the situation and the subject. Sometimes I do miss a photograph or two, but in the long run reading greatly increases my patience, and I would guess that I get many more photographs as a consequence.

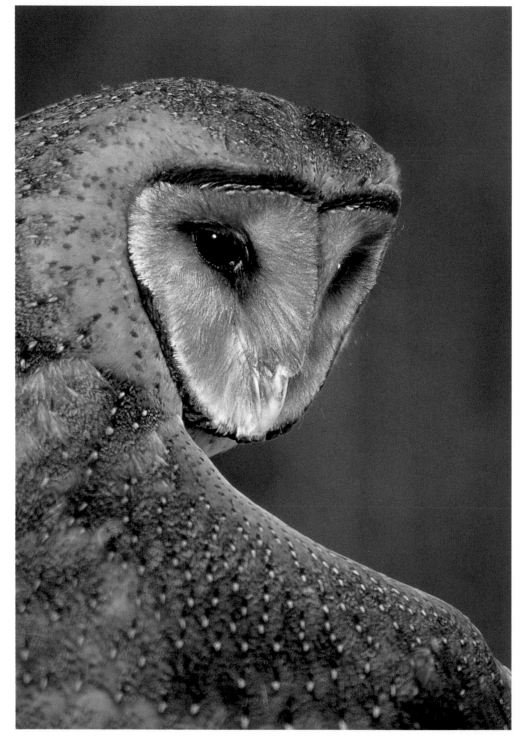

Barn owl, Foothills Raptor Center, Tennessee
Nikon 90s, 400mm lens, Fuji Provia
Jane Ashley

Photographing birds at a raptor rehabilitation center in Tennessee, I used a long lens to isolate the line of the owl's head and wing, as well as the design of the feathers.

OPPOSITE PAGE
Male and female sage grouse, Oregon
Nikon F5, Nikon 600mm lens, Kodak E100SW
Steve Carlisle

Using a beanbag as a rest for my lens, I made this photograph from my truck window at daybreak near the Malheur National Wildlife Refuge in Oregon in early March. Seventeen male grouse were displaying and vying for the approval of the females present. This male successfully attracted this female; mating took place shortly after I made this shot.

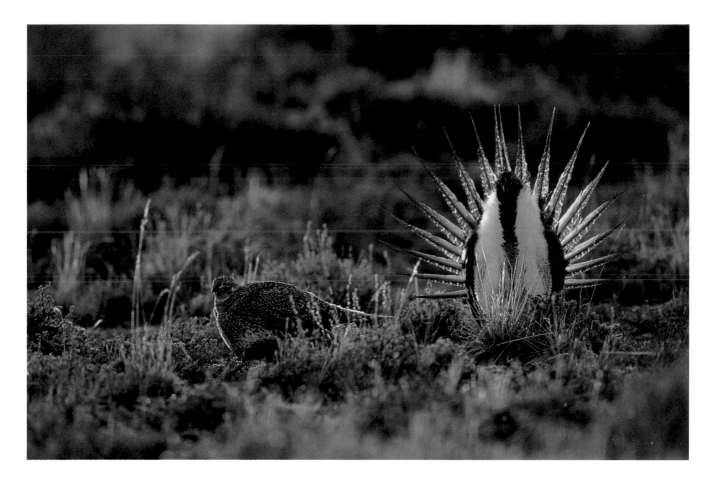

SHOOTING FROM A VEHICLE

In many areas, the resident mammals and birds have become habituated to vehicles and will allow a car, truck, or van to approach very closely. Certainly the animals see the human passengers inside, but they don't associate them with danger. If you step outside, however, they'll often disappear in an instant. You can shoot from a vehicle a couple of different ways. If you own a van with a door that opens on the side, you can sometimes set up a tripod and shoot as you would if you were on the ground. If you have someone with you who can drive the vehicle, position yourself and open the sliding door before you approach the subject. The metallic noise of a door opening can startle animals and ruin the shot.

If you're traveling alone, you'll usually shoot from the driver's seat. In this situation you have three shooting options: handholding, using a window mount, and using a beanbag. I don't recommend handholding at a shutter speed any less than the focal length of the lens you're using. For example, I would rarely shoot a 300mm lens at a speed of less than 1/400 sec. Since the light will often be too dim for you to handhold your camera and still get a sharp image, you'll need either a window mount or a beanbag. Many different window mounts are available from photo-supply catalogs, and none of them is much better than the others. In most of them, the mount hooks on the lip of the window and is braced against the inside of the vehicle door.

Window mounts are designed to accept a tripod head on top, which makes it easy to track a moving subject.

Even so, I've always had problems with window mounts. The insides of most vehicle doors are padded and spongy, and because of this the brace that leans against the door doesn't rest on a rigid surface. This makes the window mount bounce when a heavy lens is mounted on it.

When I'm using a large lens—600mm or 800mm—I prefer to use a beanbag. It is steadier than a window mount and can support the largest of telephoto lenses. The down side of the beanbag is that it is difficult to pan and follow a fast-moving subject. In the end, neither the window mount nor the beanbag is perfect, and each has its own merits.

Even though an animal will often let a vehicle approach closer than it will a person on foot, it might still be very wary and nervous. Another trick that has worked for me is to place black curtains across the inside of all the windows in my Jeep, which converted it into a mobile blind. This shooting arrangement recently worked very well when I was photographing a red-tailed hawk nesting beside the road, as well as when I was working at the den of a red fox in a roadside ditch. In both cases, the critters were always nervous when I was parked nearby, and they relaxed only after I added the curtains. I now have permanent pieces of Velcro glued to the inside of my vehicle, and I can install the curtains in a couple of minutes. If you can, hang the curtains before you approach your subjects so they never see you inside.

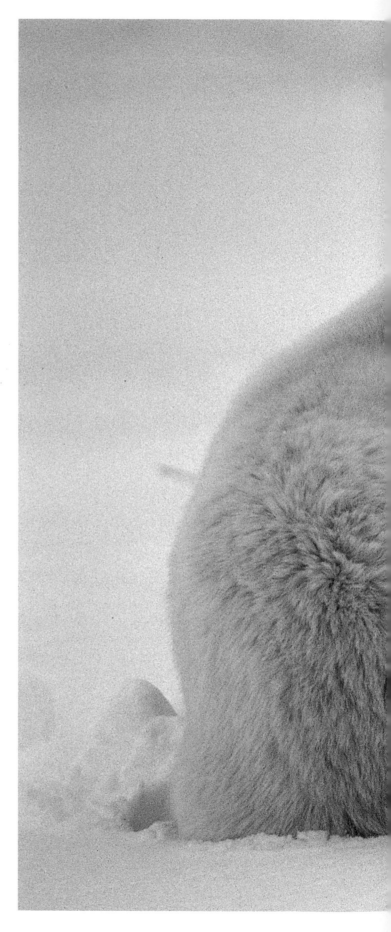

STALKING ON FOOT

In many parks, wildlife refuges, and campgrounds, the wildlife is ridiculously tame, and you can approach on foot in the open. So it is no surprise that photographs of Florida waterbirds and bugling elk are so common. Travel to Ding Darling Wildlife Refuge in Florida any winter or to Yellowstone any September, and you'll be amused and entertained by the hordes of wildlife photographers lurking by the side of the road and stalking the woodlands. Many of these photographers will go home with wonderful wildlife shots, and some might even capture interesting behavior on film. There is no doubt that shooting in these locations and in this way can be great fun, and is a delightful way to practice photographic technique. Don't expect, however, to capture the elusive or the unusual. I think all photographers want their work to be unique and distinctive, and certainly the easiest way to achieve this is to leave the crowds behind and set up a blind.

I built my first blind in 1972. It was an ugly piece of old canvas hung over a frame of aluminum poles, but it did the job. I erected the blind in 3 feet of water, 40 feet offshore from the nest of a common loon in northern Canada. When the loon first returned and leaped onto the nest, I was sure the bird would be frightened away by the loud pounding of my heart. Since then I've photographed hundreds of animals from blinds, and the excitement has never lessened. It is a big step for a nature photographer to start using a blind, but once you do, wildlife photography will change forever from a pastime to a passion.

Polar bear family, Churchill, Manitoba
Canon A2, Canon 600mm lens, Fuji Sensia
Richard J. Demler

After I followed this active female and cubs since early morning, the composition I'd been waiting for materialized late in the day. As the bears prepared for a nap, I set my 600mm lens on a window mount and held their attention long enough to capture this image.

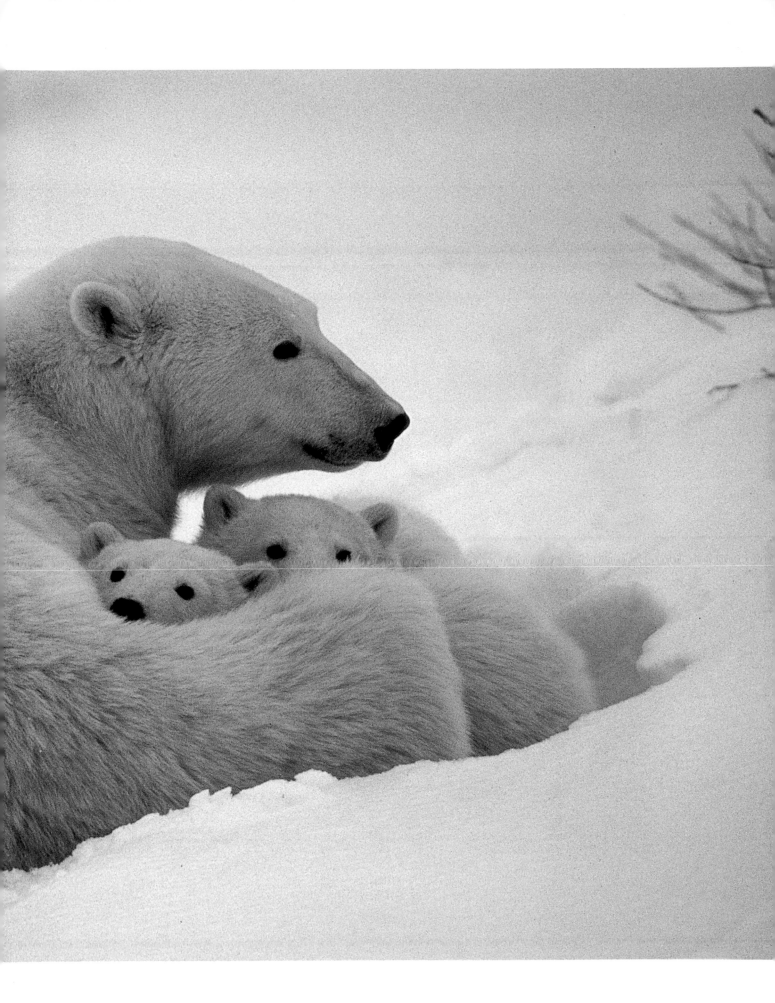

Ring-necked pheasant and hay bale, McClure, Pennsylvania
Canon EOS-1, Canon 600mm lens, Fuji Velvia

Samuel R. Maglione

One morning I noticed this pheasant on a farm in central Pennsylvania. I determined its likely path and took a low position in a ditch to wait for the bird to come to me. I recorded the scene with a very long focal length, 600mm, plus a good measure of patience and luck.

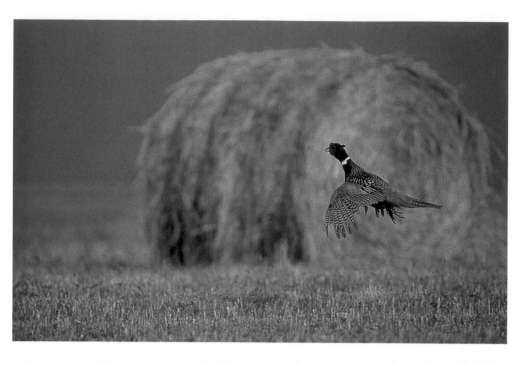

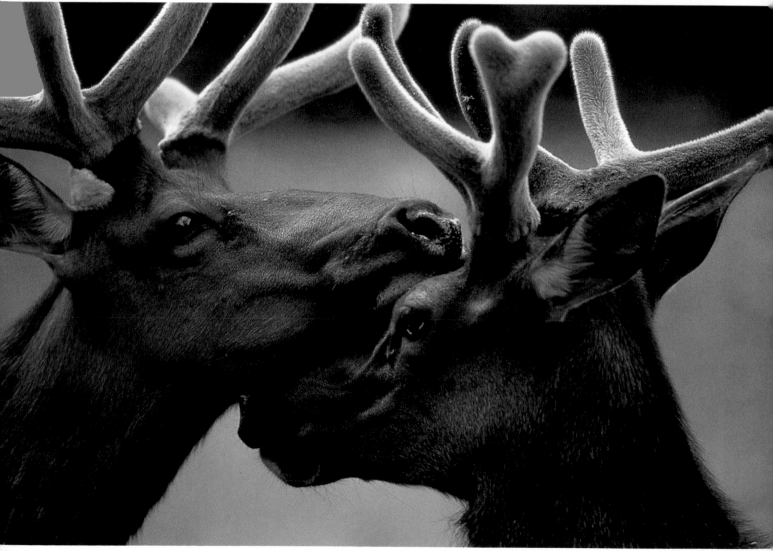

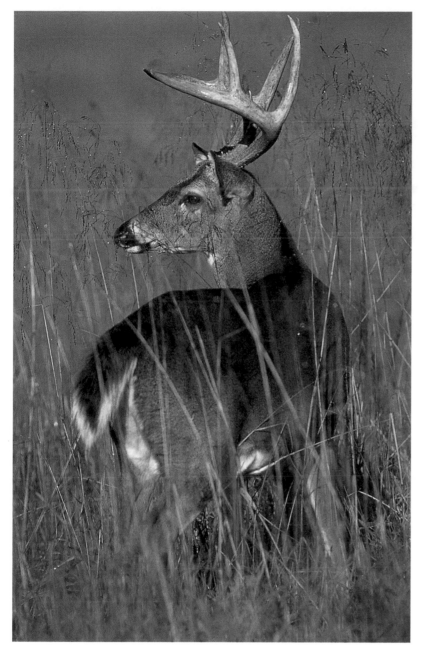

White-tailed buck, Cades Cove, Great Smoky Mountains National Park, Tennessee
Canon F1, Canon 500mm lens, Fujichrome 100
Ken Chiles

While photographing fall color in Cades Cove, I found a group of white-tailed bucks. Using my 500mm lens enabled me to isolate this one from the group.

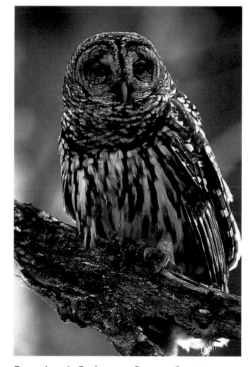

Barred owl, Corkscrew Swamp Sanctuary, Florida
Nikon N90s, Nikon 300mm lens, fill flash, Kodak Lumiere
Christopher C. Leeper

I spied this barred owl resting on a low tree limb merely 15 feet from the boardwalk in dappled, rich morning light. My 300mm lens enabled me to fill the frame with the sleepy bird. I handheld my flash off-axis to add both some fill and a catchlight in the owl's eyes.

Elk pair, Banff National Park, Alberta, Canada
Nikon F4, Nikon 500mm lens, Fuji Velvia
Mark D. Baker

This pair of elk was grazing along the road in Banff National Park. I was using my 500mm lens to get individual portraits of each when they came together for a few moments. Although a small crowd of onlookers had gathered, the elk were unconcerned until a busload of excited (and unsupervised) tourists arrived and scared the pair into the woods.

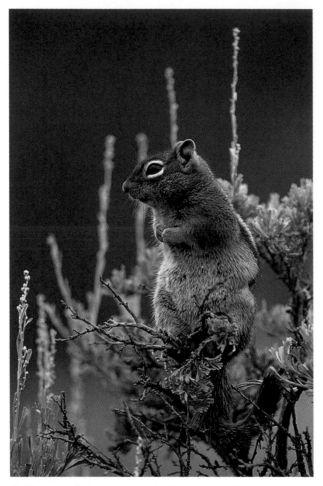

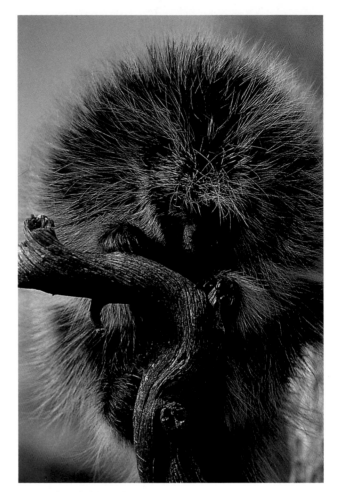

Golden-mantled ground squirrel in sage bush, Crested Butte, Colorado
Nikon N90s, Nikon 500mm lens, Kodak E100SW
Lloyd Williams

I spotted this ground squirrel climbing into a sage bush while I was driving along a dirt road. By using a 500mm lens from behind the car, I was able to spend about twenty minutes photographing without disturbing it.

Porcupine, Bridger Canyon, Montana
Nikon N90s, Nikon 300mm lens, fill flash, Fuji Sensia
John B. Davidson

This porcupine was perfectly situated in the late afternoon. I used a weak fill flash to capture a highlight in the eye while letting the natural sunlight provide the backlighting.

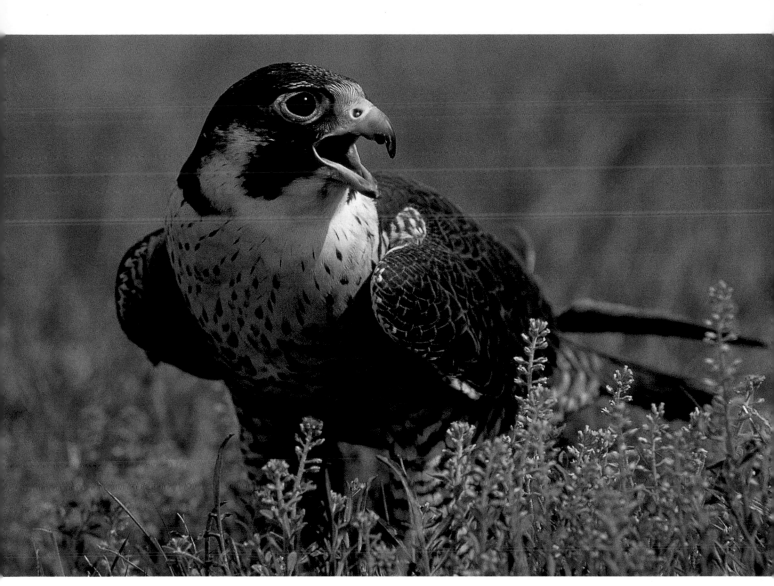

Peregrine falcon, Colorado
Nikon F5, Nikon 500mm lens, Fuji Sensia
Bruce Lytle

When I first start photographing a subject, such as this falcon, I try to get as many traditional images as possible. Once this is done, I settle in to wait for the subject to provide me with a pose or reaction that helps define it and stimulate the viewer.

Bill Fortney
SELF-ASSIGNMENTS

Many years ago I started my professional life as a high-school teacher and football coach. The standard chant of coaching was: fundamentals, fundamentals, fundamentals, and practice, practice, practice! This is more than a mantra. In sports the chances of playing your best when it counts, involves knowing the fundamentals and acting them out precisely! In football, the more you practice blocking, tackling, passing, kicking, and running the better you'll perform under the pressure of the game. Photography is no different. If you understand the fundamentals of photography and apply those fundamentals over and over in practice sessions, you'll make the outstanding images you desire when you get that great light or terrific subject. During my twenty-six-year career as a working pro, I've blown it more than once because I wasn't really ready to shoot when an opportunity presented itself. For example, when I was a young press photographer, I once was assigned to cover a

visit by President Nixon to my state. I photographed him with three cameras, but only one had film in it! Ouch! You can bet I learned a lesson.

Today many working professional photographers are self-educated. We picked up a camera and fell in love with the craft of photography. We went to the library and picked up a few books on photography. We shot a lot of film. Many of us had a mentor that looked at our work and spent a little or a lot of time showing us all of our mistakes and helping us do better the next time. It wasn't too long until we understood enough about exposure, depth of field, motion rendition, composition, and light to go off on our own and learn in the school of hard knocks. This part of our education required trying, failing, and then trying again.

You'll find that rather than just throwing up your hands and figuring you'll try again next time, practice. Practicing with a purpose is the self-assignment. The more you repeat

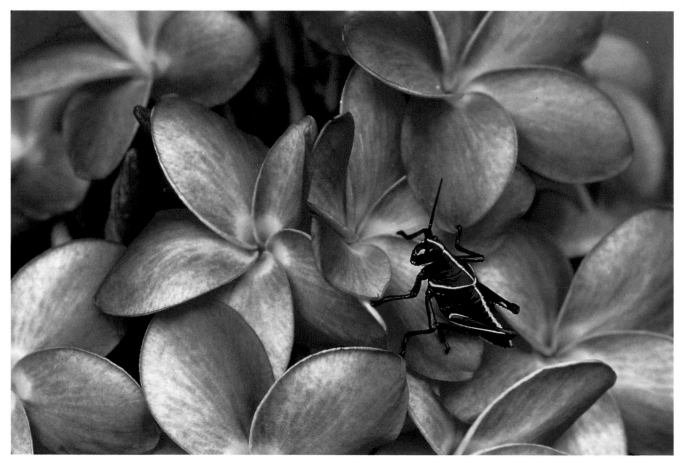

Lubber grasshopper on frangipani
Nikon F3, Nikon 105mm macro lens, Fuji Velvia
Kevin Barry

A docile grasshopper, a gorgeous tropical flower in full bloom, and an overcast day added up to a perfect photographic opportunity, which I captured with my 105mm macro lens.

that sequence, the better your photography will become. The self-assignment is simply a way to focus those efforts into blocks of information that you need to master.

Suppose that when some of your photographs come back, the focus isn't right, the foreground isn't sharp, or perhaps the background is too sharp and distracting. If this has ever happened to you, it might be time for you to learn a little more about depth of field. So if you don't completely understand this concept, you should do an assignment that will help you become completely familiar with the principles involved.

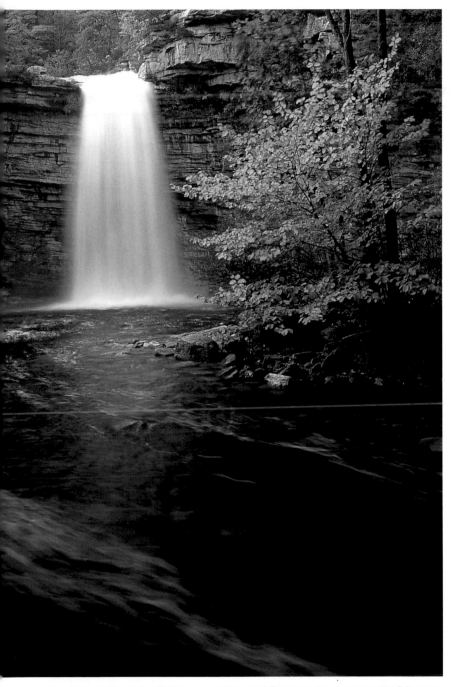

B. Reynolds Falls, Ricketts Glen State Park, Pennsylvania
Canon Rebel XS, Tamron 28–200mm lens, Fuji Velvia
Scott E. Brown

With a zoom lens I was able to explore this scene until I found a composition that isolated the falls and placed the bright yellow foliage at the upper left power point. A 20-second shutter speed filled in the thin veil of the falls.

Awosting Falls and autumn beech tree, Minnewaska State Park, Ulster County, New York
Nikon FM2, Nikon 35mm lens, Fuji Velvia
Steven Valk

Using my 35mm lens let me isolate the falls and a portion of the water flowing downstream, yet eliminate the overcast sky. I stopped down to f/16 for maximum depth of field.

ASSIGNMENT 1:
UNDERSTANDING DEPTH OF FIELD

First, find a scene with some object—flowers, a rock, a fence—in the foreground and where the background is some distance away, at least several hundred feet. Now determine your exposure using an f-stop of f/ 16 or f/22. Focus about a third of the way into the scene. Shoot a few frames. Everything in the frame from right in front of the lens to infinity should be in sharp focus. You can use your depth-of-field preview button to confirm this. Next, shoot a second roll of film, keeping the subject sharp and clear, and the foreground and background completely out of focus. You do this by choosing an f-stop in the f/2.8 to f/4 range. As you compare the shots from the two rolls, think about how each effect alters your emotional response to the photograph.

The third step in this self-assignment is to take one shot at each f-stop on your lens. When you get your slides or prints processed, examine the effect each f-stop causes. It is a good idea to keep some notes during this part of the assignment so that you can figure out which slides you shot at which f-stops. Some images will be sharp from front to back; such pictures are described as exhibiting great depth of field. Other images will have only a sharp foreground. The rest of the image will show more or less depth to varying degrees.

Why would you decide to have extensive depth of field or very little? My good friend, photographer Bryan Peterson, has a wonderful way of explaining this very question. To quote him, "story telling" is the process of showing all that is in the scene and how these elements relate to each other. When you want to tell the whole story, you want lots of depth of field. So you must choose a small f-stop, which is also called an aperture setting, such as f/32, f/22, or even f/16.

Soleduck forest and stream, Olympic National Park, Washington
Nikon F4s, Nikon 24–50mm F3.3 lens, Fuji Velvia
Michael Montgomery

My 24–50mm is a favorite lens that offers great versatility. I used this short zoom lens to facilitate specific framing of the stream and surrounding environment. The lens enabled me to include enough of the trees to show the lushness of the forest, as well as to crop tight enough to eliminate the sky.

OPPOSITE PAGE
Sunstar and snow on pines, Targhee National Forest, Idaho
Nikon N8008, Tamron 28-80mm lens, Fuji Velvia
Marlene Nau Leistico

With my zoom lens set at its widest focal length, I waited for the sun to appear from the back side of the tree before firing off several frames on this previsualized scene. Using an aperture of f/22 created the sunstar effect.

Dewdrop on grass, Grand Teton National Park, Wyoming
Nikon N90, Nikon 105mm macro lens, Fuji Velvia

Tom Myers

While shooting one morning in Grand Teton National Park, I noticed that the dew on the grass was acting like a lens and picking up the image of nearby wildflowers. The grass and the image in the dewdrop were in two different planes, making it difficult to render both in focus.

BELOW
Poppy fields, Antelope Valley, California
Nikon N90, Nikon 20mm lens, Fuji Sensia

Nancy Hoyt Belcher

I was traveling to the Antelope Valley Poppy Reserve when I spotted this field of flowers just south of Palmdale, California. I drove off onto a frontage road, set up my tripod as close to the ground as possible, and shot several frames between gusts of wind.

ABOVE LEFT
Morel mushrooms and violets, Crawford County, Wisconsin
Nikon F3, Nikon 55mm macro lens, Fuji Velvia
Richard LaMartina

I manipulated my tripod in order to straddle this compact group of morel mushrooms and position my camera so that I could maximize depth of field. The day was bright and sunny, so I used a diffusion screen to soften the light, then shot the morels with my 55mm macro lens.

ABOVE RIGHT
Pine cones, Black Hills, South Dakota
Canon A2, Canon 28-105mm lens, Fuji Velvia
Barbara Warren

Overcast weather provided wonderfully soft lighting for these pine cones. I mounted my camera on a tripod, aligned the camera body parallel to the ground, and shot at f/11 to get good depth of field and the best optical quality.

LEFT
Ladybug larva on bluebonnet, Dallas Nature Center, Texas
Pentax LX, Vivitar 100mm macro lens, Fuji Velvia
Clark Crenshaw

I spotted this interesting creature while I was on a camera-club field trip to the Dallas Nature Center. I used a wide-open aperture so that the larva and only a portion of the flower would be in sharp focus.

Sometimes, however, you want to separate the subject from its surroundings, making it stand alone and apart from the foreground and background. Peterson calls this "isolating the subject." It requires selecting *f*-stops in the *f*/2.8 to *f*/4 range. He has also defined another category relating to depth of field. In a "who cares?" shot, it isn't really important to isolate the subject or create lots of depth.

For these kinds of photographs, Peterson just uses an aperture of *f*/5.6 or *f*/8.

After going through this self-assignment a few times you'll begin to get a real sense about how much depth of field is needed for a particular photographic situation and how to make that effect happen! Now you're gaining some true control over your results!

Whitetail deer fawn twins, Kensington Metropark, Milford, Michigan
Nikon F3, Nikon 80-200mm lens, Fuji Velvia pushed one stop
Ted Nelson

The challenge of this photograph was to get the depth of field needed to yield a sharp image of both fawns, one behind the other. Shot at *f*/16 and with shutter speeds around 1/2 or 1/4 sec., several frames were spoiled by the casual movement, even breathing, of the fawns.

RIGHT
Avalanche lilies and Mt. Rainier, Indian Henry's Hunting Ground, Mt. Rainier National Park, Washington
Nikon N8008s, Nikon 24mm lens, Fuji Velvia
Rod Barbee

From the first time I saw this breathtaking carpet of flowers, I knew I wanted to capture it on film. Returning to the back-country location of Mt. Rainier National Park on a brilliant July morning, I used a polarizing filter to help saturate the greens. I also used a one-stop, graduated neutral-density filter to keep the whites of the mountain within the latitude of the film. Then it was just a matter of waiting for the light breeze to subside.

ASSIGNMENT 2:
EXPERIMENT WITH MOTION

One of the other major decisions you must make when you take a photograph is figuring out how you want to render motion. Usually photographers want to stop it and capture a single moment in time—in fact, a fraction of a second. If you don't use a fast enough shutter speed when photographing sports, children playing, people walking, or puppies running, you'll end up with an artistic blur on the film. If that is the effect you want, then you did exactly the right thing; if not, you need some practice.

Your camera's shutter-speed control is directly involved in the rendition of motion in your photographs. The shutter is a small opening in the camera right in front of the film, and acts like a curtain. As this curtain opens and closes, it determines two things: how much light strikes the film and how motion is captured on the film. Obviously, the longer the curtain remains open, the more light strikes the film, and the more motion is allowed to reach, or paint onto, the film. If the subject is moving at all, a fast shutter speed is required to stop that motion. For example, a person walking parallel to the camera probably needs a shutter speed of 1/125th of a second, shown on the camera as 1/125 or sim-

ply 125. All shutter-speed markings are fractions of a second or full seconds.

For this assignment, take another roll of film and go out and find a subject you want to photograph that is in motion. You might, for example, go to a park where people are jogging, walking, or playing and shoot some photographs at shutter speeds of 1/125 sec. to 1/500 sec. Next, with your camera on a tripod, shoot a few more images of the same subjects with shutter speeds of 1/2 sec. to 1/8 sec. Remember, once again, to keep good notes so you can properly identify which shots you took at slow shutter speeds and which ones you shot at fast speeds. When you get your film processed, compare the images. These side-by-side comparisons will enable you to recognize when you would want to use a slow shutter speed. For my nature work, I use slow shutter speeds a lot to show water flowing, such as in a waterfall or a stream, and when I want to give the ocean a smooth, silky appearance.

Just keep in mind that fast shutter speeds stop action, and slow shutter speeds register motion as a blur. Sometimes you'll need an action-stopping shutter speed. On other occasions, you'll want to render motion artistically blur. The choice is up to you and the shutter-speed dial!

Dog-Slaughter Falls, Corbin, Kentucky
Nikon FE2, Nikon 35mm lens, Fuji Velvia
Robert Johnson

Dog-Slaughter Falls is in Corbin, Kentucky, in the Daniel Boone National Forest. To reach the falls, you have to hike along Dog-Slaughter Creek for 1 1/2 miles. I added a polarizer to my 35mm lens to saturate the colors in this shot.

Starfish, Sanibel Island, Florida
Nikon F4, Nikon 24mm lens, fill flash, Fuji Velvia
J. R. Schnelzer

I used a 24mm wide-angle lens to isolate a single starfish as the sun set over Sanibel Island. Realizing that using Velvia film would create a long exposure, I decided to add a small amount of fill flash using a Nikon SB-24 flash set at -.7. Using the flash in the rear-synchronization mode enabled me to retain the movement of the water.

LEFT
Pacific white-sided dolphin, Johnstone Straits, British Columbia, Canada
Nikon 8008s, Tamron 70-210mm F8 lens, Kodak Lumiere
Peter Hartlove

Each day while I was whale-watching in Johnstone Strait, many Pacific white-sided dolphins happily swarmed near the boat, riding the wake. Leaning over the railing, I used a 70-210mm zoom lens to allow flexibilty to capture this individual.

Tree reflection, Bond Falls, Paulding, Michigan
Nikon N70, Nikon 75–300mm lens, Fuji Velvia
David L. Mitchell

Shooting at Bond Falls in Michigan's Upper Peninsula proved to be a magical photographic experience. My 300mm focal-length setting enabled me to limit the patterns I was attempting to capture. In this instance aperture proved more important than shutter speed.

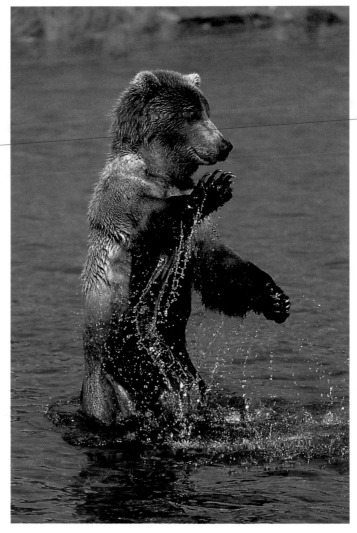

Alaskan brown bear standing in water, Katmai National Park, Alaska
Nikon F4, Nikon 500mm lens, Fuji Provia
Katherine Feng

Katmai National Park is one of the best places to photograph brown bears. If you visit the park during a salmon run, you'll have many opportunities for great shots.

ASSIGNMENT 3:
USING LENSES EFFECTIVELY

One of the really fun parts of photography is all those beautiful glass gems you can buy for your camera called lenses. I've never met a photographer who doesn't love to collect them. But, remember they are tools and to get the best possible image on film, you need to know how to use them to the fullest.

Here is the assignment. Go into the field for a day of shooting, and take only a single lens. For example, shoot for a full day with your 24mm lens. On another day, bring only your 300mm lens, and on yet another day bring only your 80–200mm zoom lens. Get the idea? Working with a single focal length forces you to see how many different subjects you can handle with that lens. This experiment actually teaches you more about when and how a specific lens will be most useful.

Keep in mind the following tips as you do this assignment with different lenses. The 20mm to 35mm wide-angle lenses take in more of the world, tend to make the scene look expanded, and stretch out your sense of the scene. If you want to take a photograph of your yard that makes it look much larger than it really is, use a wide-angle lens. One great technique for working with this kind of lens is to find a compelling foreground object and then move the front of the lens very close to that object to let it anchor the foreground. Then choose a small *f*-stop setting, such as *f*/22, and shoot. This approach give you tremendous depth of field and expands the perspective of your scene.

With telephoto lenses, the angle of view is narrow, and the resulting photographs look compressed. Suppose, for example, you're photographing mountains in the distance. They'll look much closer than they actually are if you use a telephoto lens. You can use this technique to great advantage when you want to stack objects in the frame, such as mountains in the mist, trees in a line, or anything else that you want to appear close together for effect. As you can see, photography has little to do with reality. It is the artistic expression of arranging subjects in the frame to make a pleasing image, one with real impact.

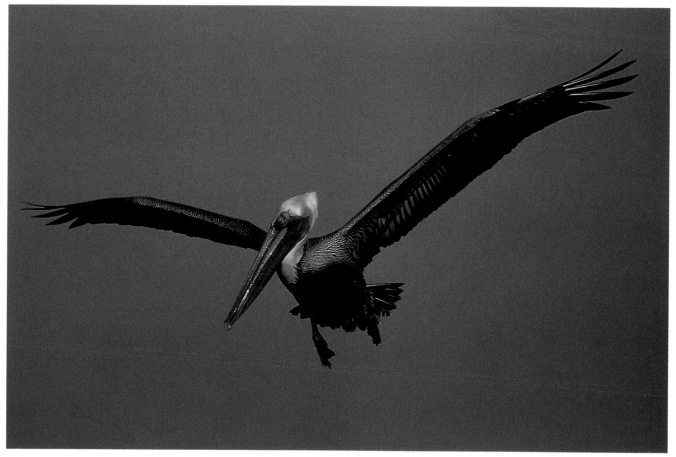

Endangered brown pelican in flight, Bolsa Chica Reserve, California
Canon EOS-ln, Canon 500mm lens, Fuji Sensia
Bradford J. Haney

With storm clouds all around, I'd been watching a group of pelicans fishing nearby. Just as the sun popped out from behind a cloud, one of the birds flew directly at me. I captured this image as the bird stalled out, right before diving into the ocean.

Otter Cliffs, Acadia National Park, Maine
Nikon N90, Nikon 80–200mm lens, Fuji Velvia
Chuck Summers

I carefully scrambled over several rocks in the dark to set up my camera facing Otter Cliffs in Acadia National Park. I used my 80–200mm zoom lens to capture the ocean spray at sunrise breaking upon the rocks along the rugged coast.

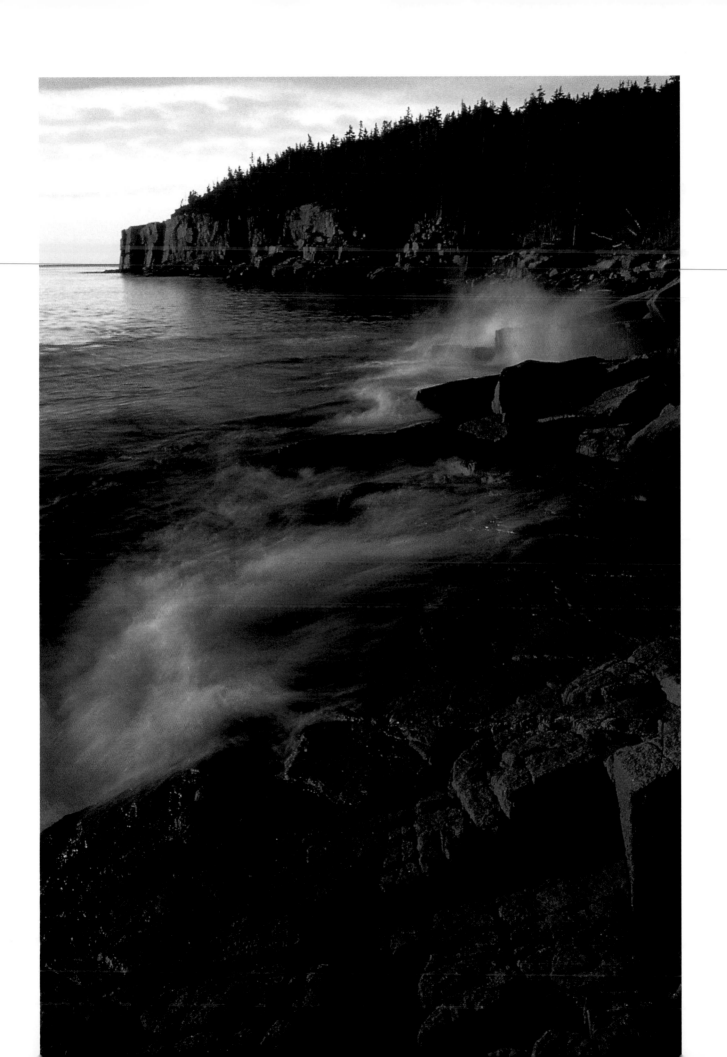

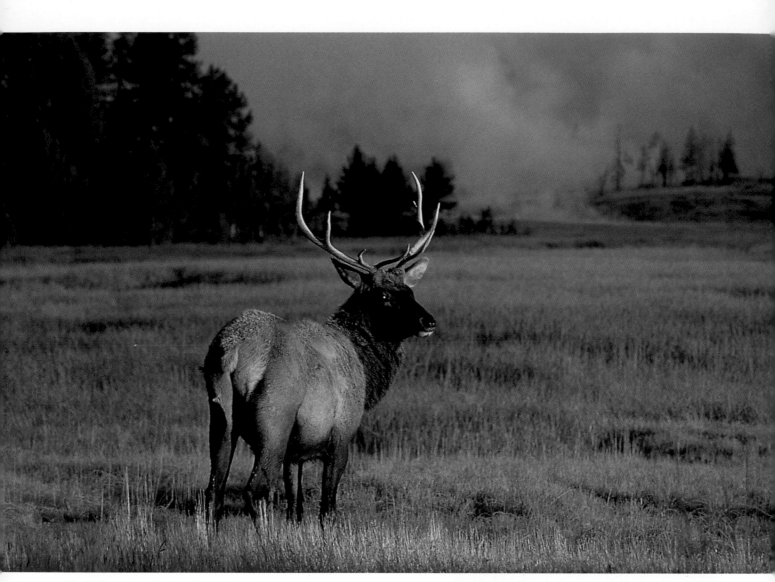

Elk, Yellowstone National Park, Wyoming
Nikon N90s, Nikon 70–210mm lens, Fuji Provia
Vera Kalnins

By using the 200mm focal length on my 70–210mm zoom lens, I was able to bring the elk closer and still include the Yellowstone scenery in the background.

Maple and birch, Moosehead Lake, Maine
Nikon 6006, Nikon 70–210mm lens, Fuji Velvia
Darren Guyaz

As I explored a back road near Moosehead Lake, the contrast of red maple leaves against the white birch trees caught my eye. By focusing on one small section of the grove, I was able to capture this moment.

Autumn maple tree, Lost Maples State Natural Area, Texas
Pentax LX, Sigma 70–210mm lens, Fuji Velvia
Clark Crenshaw

I made this image with my 70–210mm zoom lens set at about 150mm. I was able to isolate the elements that attracted me to this scene: the design of the trunk and limbs with the colorful leaves around it.

Autumn color on Nason Ridge, Steven's Pass, Washington
Canon A2, Canon 70–200mm lens, Fuji Velvia

Stephen Matera

The Cascade Mountains aren't known for their fall colors, but they have some great displays. I set my 70–200mm zoom lens at about 135mm to isolate this section of Nason Ridge. I wanted to show the contrast of the deciduous and evergreen colors.

93

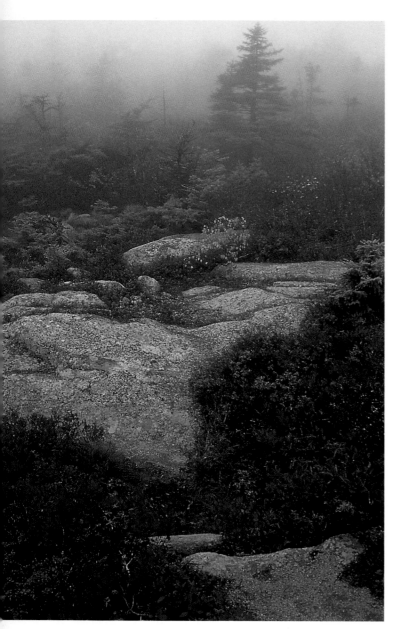

Foggy morning, Acadia National Park, Maine
Nikon N8008s, Nikon 24–50mm lens, Fuji Velvia
Cheryl Barnaba

Early-morning fog adds mystery to this autumn landscape on Cadillac Mountain in Acadia National Park. A 24–50mm zoom lens enabled me to accentuate the foreground while achieving maximum depth of field.

MASTERING EXPOSURE

I am sure that the most-often-asked questions at photography workshops, ours included, are about how to get correct exposure. This is an area where everyone need to do a self-assignment. Exposure isn't hard to learn, but it does take some discipline and some clear logical thinking.

Let me walk you through the basics for a moment. The camera's meter is designed to interpret anything you point it at as medium in tone, which means it reflects 18 percent of the light. Simply put, this tone is halfway between black and white, or halfway between extremely dark and extremely light. Camera companies design meters this way for a good reason: most scenes people photograph average out to being medium tone overall. Sometimes, though, you shoot pictures of subjects that aren't medium-toned. The camera meter doesn't know this, so it makes an incorrect assumption and you get some bad exposures. This is the time for another kind of self-assignment.

Place your camera on manual mode. Then go out and find some scenes that you think are medium-toned overall, not extremely bright or extremely dark. Using slide film, shoot some frames at the recommended meter reading. Next, find a subject that is very, very light and one that is very, very dark. Then meter the dark and light subjects, and shoot at what the camera meter recommends for each.

The next step in this self-assignment is to go back and meter the white or very bright subject. Keep in mind that slide film has a five-stop range in its ability to record detail, and that pure white or very, very light tones are 2 to 2 1/2 stops brighter that medium tones. After taking a reading of the bright subject, open up two *f*-stops from the recommended reading and shoot a few frames. The dark subject requires the exact opposite approach. A black or very dark subject is actually two stops darker than a medium-toned subject, so meter the dark subject, stop down two *f*-stops, and make a few frames. Remember to keep notes. After all, you're trying to help compensate for an error that the meter is making. The meter thinks the very dark and very light subjects are really medium-toned, so it will suggest readings that are off by two *f*-stops. What you've just done, in essence, is correct for the meter error.

Look at your results, and see if this approach doesn't work perfectly. The more you practice this self-assignment, the more confidence you'll have that this principal works. Exposure is a critical part of the skills you'll acquire as a photographer, and this self-assignment will help you master it!

Just remember that all these controls—*f*-stops, shutter speeds, lens choices, and accessories—provide ways for you to control your photographs. Think of other ways to assign yourself opportunities to master the rest of the craft of photography. I once read a quote that said it all: "If I'm very, very careful, nothing good or bad will ever happen to me." So take some chances, and try some new things with your camera. The choices are endless, as are the opportunities to learn. Good shooting, and may your learning be as much fun as you could have ever imagined.

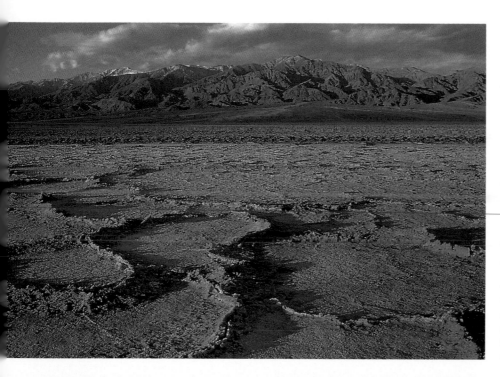

Sunrise on the Salt Flats, Death Valley, California
Canon A2, Canon 20-35mm lens, Fuji Velvia
Barbara Warren

A wide-angle zoom lens enabled me to capture the vastness of the landscape, as well as the pattern and texture of the salt flats themselves. I checked the viewfinder image carefully to avoid including the shadow of the tripod legs.

BELOW
Sand verbena and primrose, Joshua Tree National Park, California
Nikon F4, Nikon 24mm lens, Fuji Velvia
Ellie Tyler

The El Nino rains of 1997–1998 produced a spectacular wildflower display throughout the Mojave Desert. After continuous scouting, I found this location 15 miles east of 29 Palms, California, in mid-February. By shooting from ground level early in the morning after a rare night shower, I was able to convey the splendor and color of the desert floor entirely covered with blooms.

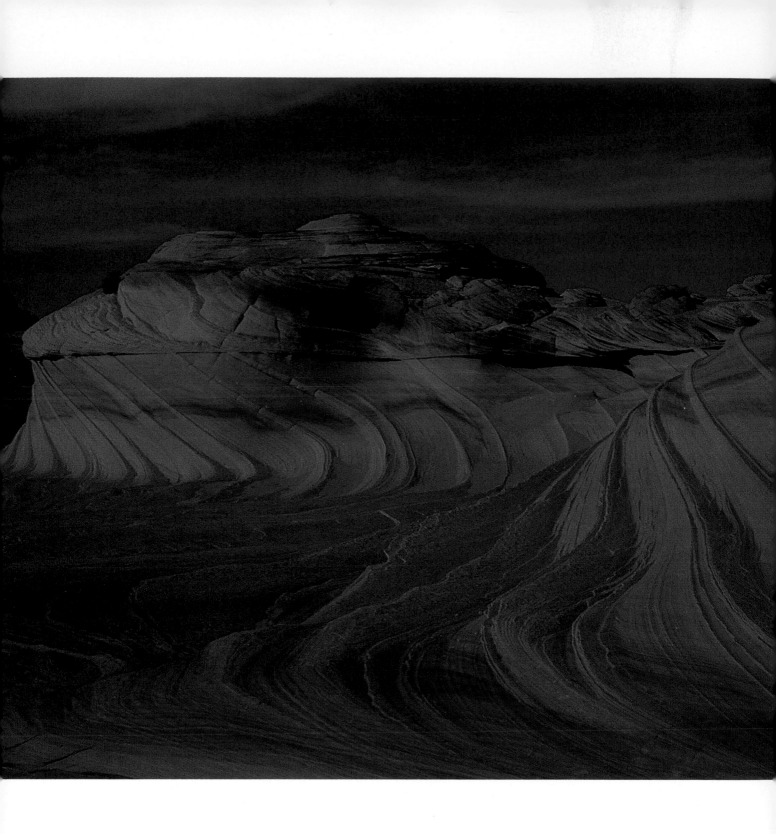

Colorado Plateau, Page, Arizona
Canon A2, Canon 35–350mm lens, Fuji Velvia
Richard J. Demler

Seeing the potential of this composition
during a hike, I waited until late afternoon
when the sun had almost set behind a ridge.
This low angle helped define the texture and
lines, while the rich, soft light enhanced the
color of the rock.

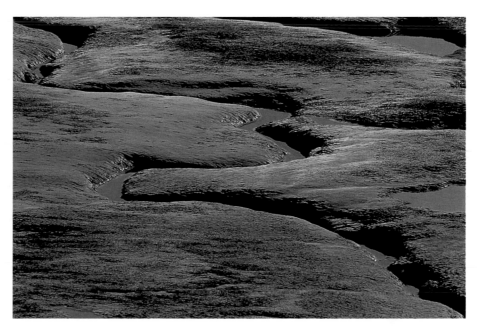

Algae, Turnagain Arm, Alaska
Canon Elan, Canon 75-300mm lens, Fuji Velvia
Ron Niebrugge

I used my zoom lens set at 300mm to isolate a small section of
the shoreline, thereby eliminating any recognizable elements. I
was looking for an abstract image emphasizing the brilliant backlit
color of the algae. Casual observers might believe that they're
looking at an aerial photograph.

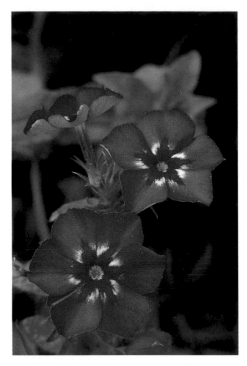

Drummond phlox flowers, central Texas
Minolta 9xi, 90mm macro lens, Fuji Velvia
Erik Pronske

Pink drummond phlox, especially when mixed with other wildflowers, provide beautiful springtime color to the fields of central Texas.

RIGHT
Orange lichens, Oiseau Bay, Pukaskwa National Park, Ontario, Canada
Nikon F4, 28–70mm lens, Fujichrome Velvia
Bruce Montagne

While shooting for a book project, I came across this spectacular rocky island along the coast of Lake Superior in Pukaskwa National Park in Ontario, Canada. Wanting to accentuate the orange lichens, I used a 28mm lens setting and shot low in a vertical format with my tripod-mounted camera. I was so engrossed in my shooting that I failed to notice my kayak floating out into the lake.

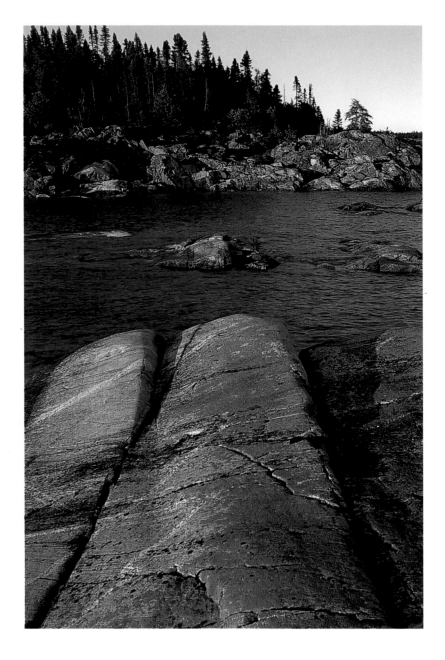

Rippled sand, Bunch Beach, Fort Myers, Florida
Canon Elan, Canon 20–35mm lens, Kodak Lumiere
Stan Grigiski

While walking on the beach, I noticed the low light from the sunrise illuminating the sand. With my wide-angle lens stopped down to f/16, I composed as close to the sand as possible, allowing the ripples in the sand to lead the viewer through the image. My main objective was to use the light to create a three-dimensional image of the sand.

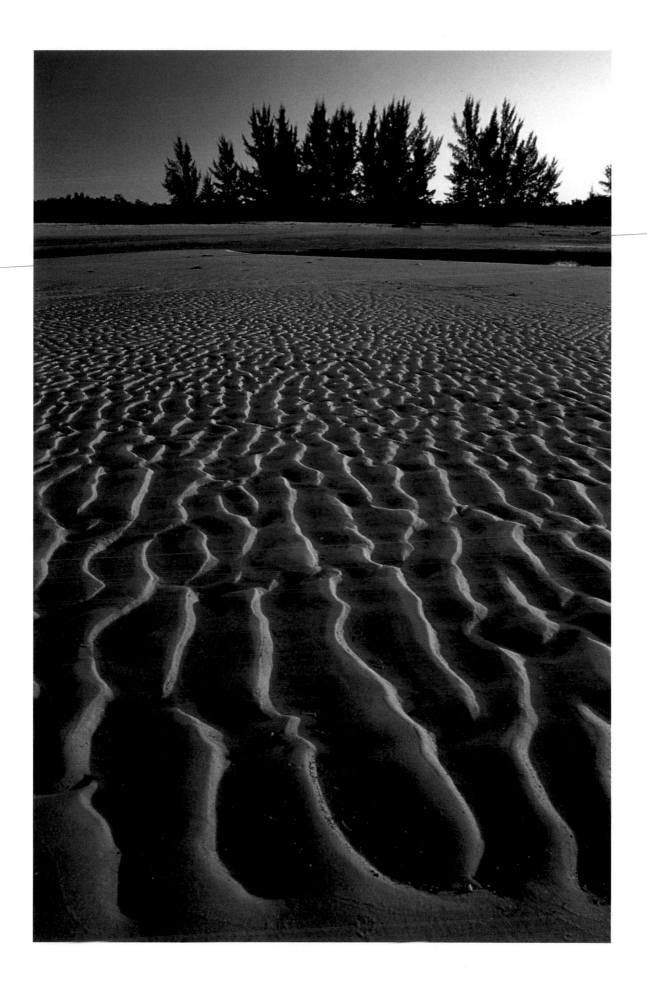

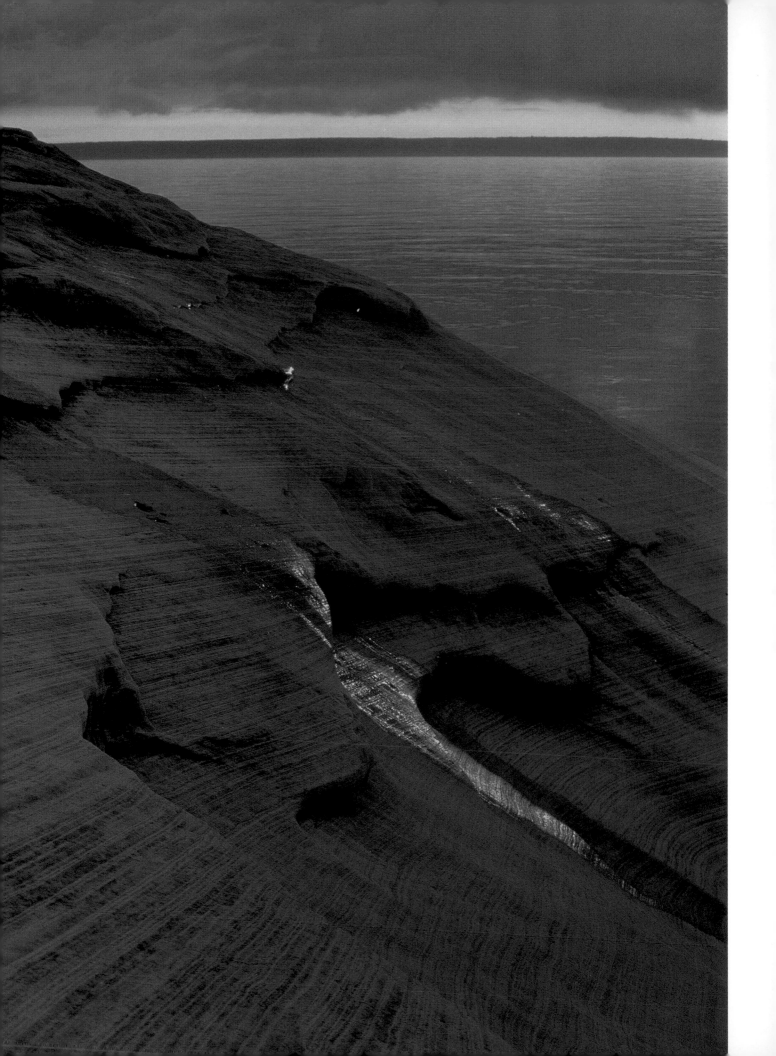

Sunset with clouds, Olympic National Park, Washington
Contax RTS III, Zeiss 300mm lens, Fuji Velvia
Martin Schwenk

After a rainy day in Olympic National Park, the sun came out for a brief moment in the late afternoon while I was at Hurricane Ridge. I captured this dramatic shot using my 300mm lens.

LEFT
Lake Superior sunset, Pictured Rocks National Lakeshore, Michigan
Nikon F3, Nikon 35mm lens, Fuji Velvia
Ted Nelson

A friend and I were shooting the Pictured Rocks National Lakeshore near Miner's Beach. This is a beautiful site, but it has been photographed so often that a fresh viewpoint seemed impossible to find. But when I turned around, I noticed the sandstone rock and water on its surface reflecting the color of the sunset. This image provides a different look at one of the most photographed locations in Michigan.

Wayne Lynch, David Middleton, and John Shaw
ON BECOMING A PRO

Imagine yourself as a participant at a photography workshop that features Wayne Lynch, David Middleton, and John Shaw as teachers. This workshop happens to be at the Tetons, but it could be at any of the many sites that Wayne, David, and John do workshops. You've decided to come to this workshop because either you've been frustrated lately with your photography and want to get better, or you are a photographer who has been frustrated lately at your job and want a better one: professional nature photographer. Either way, you are eager to pick the small but perfectly formed brains of these three pros who have figured out how to take beautiful pictures and make a living at the same time. Seventy years of combined experience have to be good for something!

In the late afternoon after a full day of shooting, critiques, and slide presentations, you're invited to join them during a break on the terrace of the lodge for a beer and some conversation. With nothing better to do, you decide to accept their unusually generous offer. You do realize, though, that with these guys, this will somehow end up costing you. After the beers arrive and all pretense of formality disappears, you decide to ask them about what it takes to become a professional nature photographer. You're hoping the answers come more quickly than the refills.

Alligator heads, St. Augustine Alligator Farm, Florida
Nikon F4, Nikon 35–70mm lens, Kodak Lumiere
Wayne M. Bennett

I noticed this group of alligators while walking along a boardwalk in a natural area in Florida. I positioned my tripod so that I could shoot with my camera over the edge of the railing.

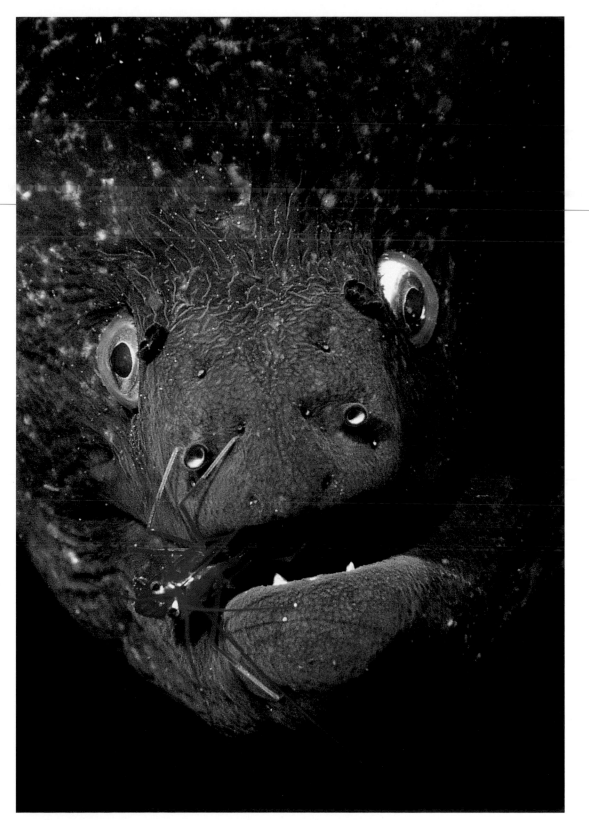

Moray eel and Red Rock shrimp, San Clemente Island, Southern California
Nikon N90s, Nikon 105mm macro lens, both in Subal underwater housing, flash, Kodak Ektachrome 100 Professional
Kenneth J. Howard

Using the 105mm lens was critical to obtaining a successful shot. Macro lenses of shorter focal lengths would require getting too close. I was able to stay about 18 inches away, enabling the subjects to become comfortable with my presence. Eventually the eel emerged from the den, and the shrimp resumed its cleaning chores.

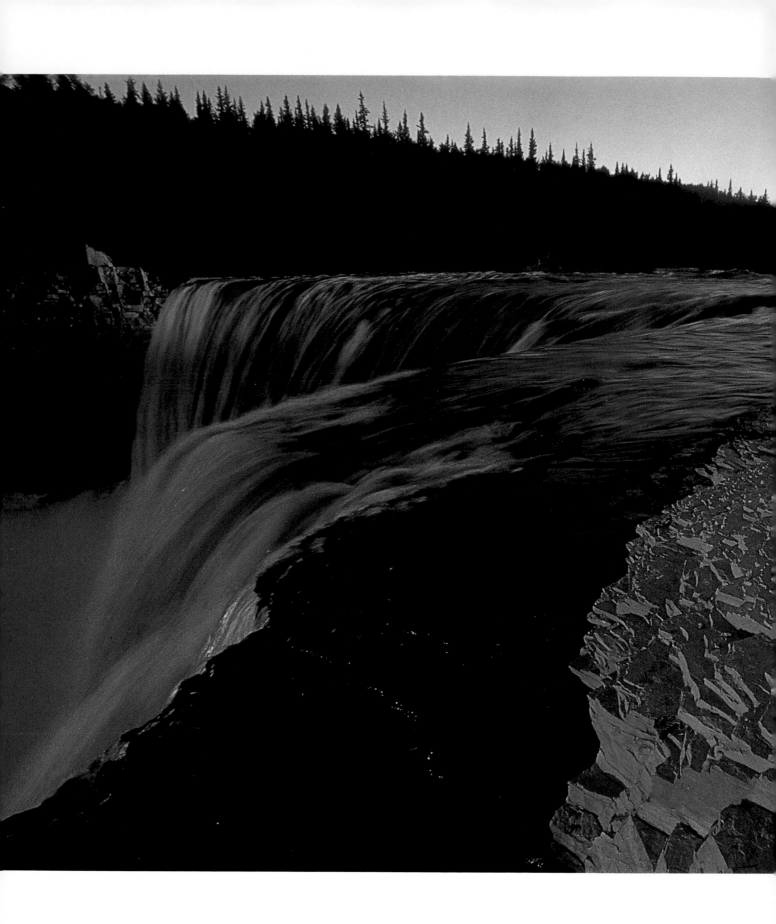

IMPORTANT CHARACTERISTICS OF A PRO

Your first question is: "What is an important characteristic of a professional photographer?" After you receive three completely blank stares in reponse, you decide to rephrase the question: "How would you define an accomplished photographer?"

John Shaw responds first. "Learning when not to photograph is just as important as learning when to shoot. This process involves learning to see your subject as your film will see it. The human eye can accommodate roughly 10 to 12 stops of contrast; that is, you can look at a very contrasty scene and see detail in both the shadow and the highlight area. Not so with film. Modern color-slide films have at most a five-stop range of light that they can record in any one image. Professional photographers have to learn how to apply this limited vision when determining exposures.

From a medium-toned, or middle-toned, exposure value, slide film can only record tones from 2 1/2 stops lighter (pure white) to 2 1/2 stops darker (pure black). Working pros have to be able to analyze a scene and determine if indeed it is possible to record their vision. They must know what the results will look like on film, even before they trip the shutter. This knowledge lets the pros decide where to place tonal values and which details to sacrifice if necessary."

David Middleton pipes up next: "I would answer by saying a pro is someone who spends more time looking for something to photograph than actually photographing it. I'm always amazed when I am out in the field and see a group of photographers pull up, jump out of their cars, walk to the nearest whatever, and begin photographing! Now, how do they know that there isn't something better to shoot just over there or around the corner? And what are the chances that they happened to park next to the best thing there is to photograph? The answer is: nil. Professional photographers get out of their vehicles and wander around first, looking over the entire area. In any one spot there are only a few things to photograph. Better to spend the time looking for those shots than waste it photographing something that could be better."

**Sunrise, Alexandra Falls on the Hay River,
Northwest Territories, Canada**
Nikon F3, Nikon 28mm lens, Fuji Velvia
Oliver Bolch

I waited at the top of 33-meter high Alexandra Falls for the sun to rise. Working with a graduated neutral-density filter on my wide-angle lens, I chose a short exposure to show single water drops against the sun. And I chose this particular view to show the power of this great river.

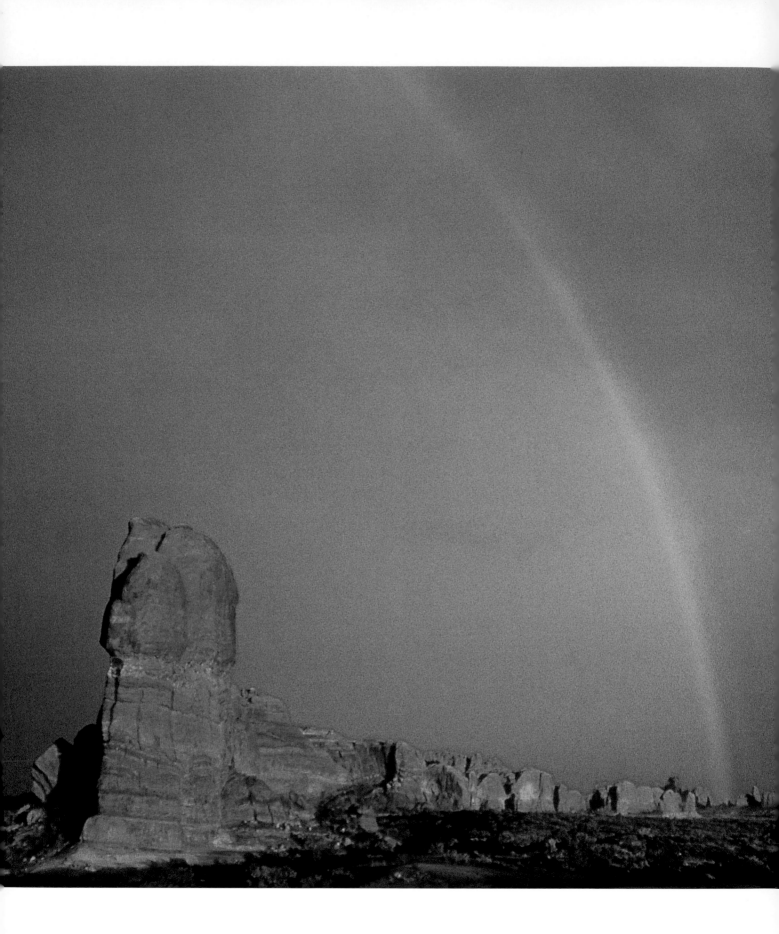

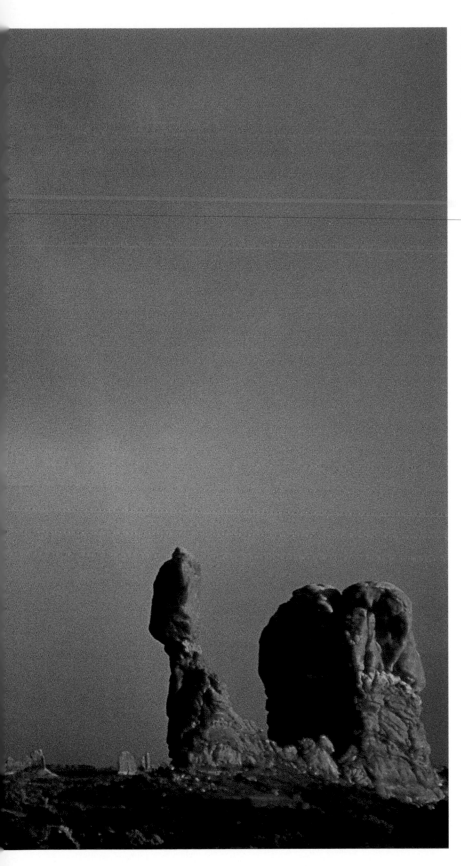

Rainbow at Balanced Rock, Arches National Park, Utah
Nikon N90s, Nikon 75–300mm lens, Kodak E100S
Marcelo Alexandre DaSilva

After a rainy afternoon I decided to wait and see if something could happen at this location—and it sure did! A window opened through the clouds on the horizon, sunlight struck the rocks, and a double rainbow formed to complete the magical moment that lasted about six or seven minutes.

Pine on Grand Canyon rim, Grand Canyon National Park, Arizona

Fuji G617, Fuji 105mm lens, Fuji Velvia

Craig Clinton Sheumaker

What to do until the sun sets? All around me people chatted, waiting to take their canyon sunset shot. But I was struck by the low light just before sunset that highlighted this pinyon pine and enabled the canyon to serve as a dramatic backdrop.

Sunset on Mount Rundle, Banff National Park, Alberta, Canada
Fuji G617, Fuji 105mm lens, Fuji Velvia
Craig Clinton Sheumaker

Patience and persistence provide handsome rewards—sometimes. I returned to the same place and stood in the same lake just about every evening for a week. The rain finally stopped long enough for the sun to peek through.

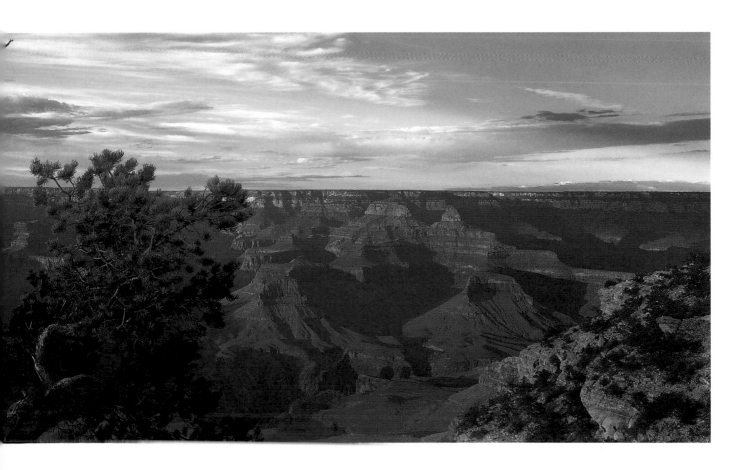

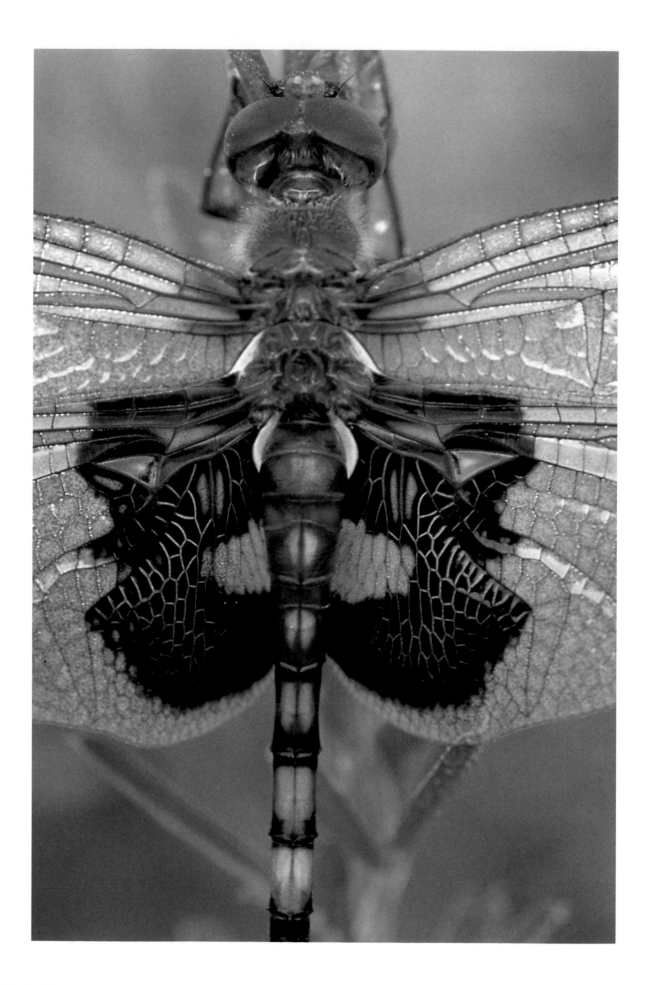

Practically bursting at this point to answer the question regarding the important characteristics of a pro is Wayne Lynch, who has spent a lifetime studying and photographing animal behavior. He knows that photographing any wild creature begins long before he steps into the field. "I think every nature photographer should also strive to be a good naturalist. Too often I've met wildlife photographers who didn't know the difference between a northern moose and a chocolate mousse. The more you know about an animal, the less likely you are to endanger it or compromise its survival. Understanding the biology of your subject will also alert you to subtle aspects of its behavior that you may otherwise overlook and fail to capture on film. Finally, knowledge of an animal is also the best insurance against injury. Many wild animals are unforgiving and will punish your clumsy ignorance with a bruising, or worse."

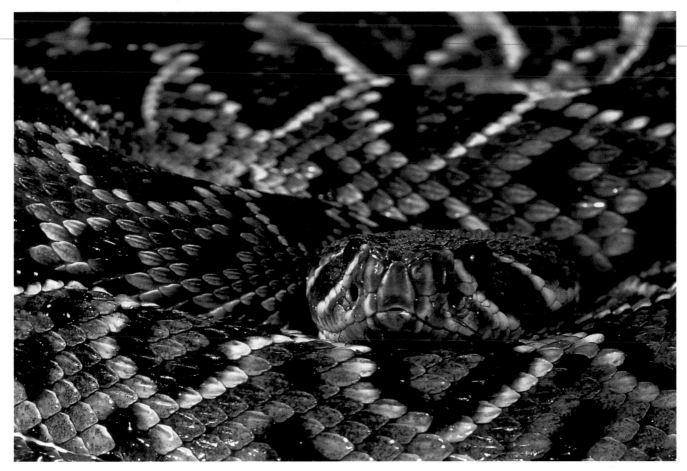

Diamond-backed rattlesnake, Pennsylvania
Nikon N90, Sigma 400mm lens, Fuji Velvia
Nancy McCallum

I used my 400mm lens in order to get a tight shot of this rattlesnake while maintaining a safe working distance. I took this photograph at a workshop that featured venomous reptiles. The workshop setting provided me with competent people to handle the snake, leaving me free to concentrate on composition.

LEFT
Saddleback dragonfly, Richmond, Virginia
Canon, Canon 100mm macro lens, Fuji Velvia
Chuck Janus

I was crossing a clearing near a site proposed for a new office park when I came upon this dragonfly perched only inches off the ground. I made this image at f/8, and redeemed what had been an uneventful morning.

SHOOTING IN THE FIELD

Your next question is a bit more practical: "How do you approach shooting in the field?"

Middleton starts this time: "Photograph what you are passionate about. Your passion will be evident into your images. If you photograph what you don't care about, your ambivalence will be translated into your images, and no matter the situation your shots will be mediocre. I also allow a lot of time in the field to just absorb what is going on around me. I'm not talking just about any animal activity, but also the play of light and the relationship of the shapes and patterns that are around. This is especially important for me if I'm coming to an area that I haven't photographed for awhile. If I don't take the time to slow down and begin seeing anew, my first rolls will be disappointing. This is another reason I think wandering is so important. Just put your hands in your pockets, and go for a stroll."

Shaw continues: "I agree. First and foremost, you should photograph the subject matter that you truly love. Even when you are a professional, there is a difference between shooting for pleasure (even if you sell the resulting photographs) and shooting solely as a commercial venture. Your emotional commitment is usually apparent in the quality of the pictures. If you like shooting all kinds of natural-history subjects, do so. If you are only interested in bird photography, fine. If all you want to do are landscapes, so be it.

Just remember that in terms of sales, it certainly helps to diversify and to have unique coverage. Some subjects have been photographed so often, and are so easy to photograph, that selling the resulting shots is very difficult. Egrets and herons from Florida, common wildflowers, Yellowstone elk, and National Park vistas shot directly from the scenic overlooks are four examples. Sure, you should have these images in your file. But if one of these subjects is all that you

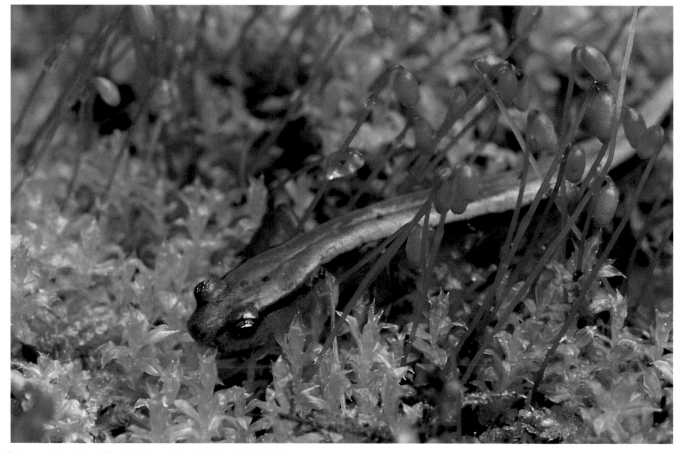

Salamander, Great Smoky Mountains National Park, Tennessee
Nikon FA, Nikon 105mm macro lens, Fuji Velvia
Ken Canning

Shooting early in the morning after a heavy rainstorm, I found this salamander meandering along a fallen log in the Greenbriar section of Great Smoky Mountains National Park. Occasionally the salamander paused long enough for me to position my tripod, compose, and shoot before continuing on its way. A 105mm macro lens is a great help in such situations. It provided a good working distance and close-focusing without my having to slow down to attach extension tubes or closeup diopters.

White-tailed ptarmigan under pine, Guanella Pass, Colorado
Nikon F5, Nikon 300mm lens, fill flash, Kodak E100S
Lloyd Williams

Ptarmigans are curious; if you're patient, they'll walk right up to you. However, I like to use a 300mm lens to avoid violating their comfort zone while I'm moving around looking for the right shot. A touch of fill flash added the catchlight.

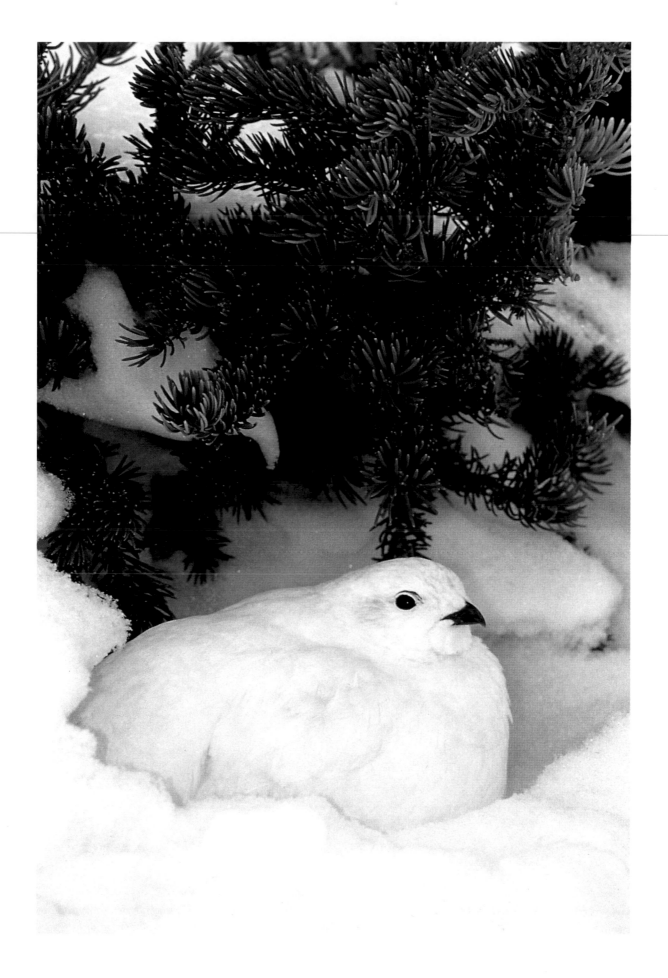

photograph, you'll have a difficult time selling many pictures. The same is true if you specialize too much. Only so many shots of bats or mushrooms are published in one year.

You should also differentiate between what is 'interesting' and what is 'photo-graphic.' Aesthetically pleasing shots will sell far more than merely 'interesting' work. This is because 'pretty' is more universal than 'interesting'. Most people agree about what is pretty, but what is interesting to you might not be interesting to me. If all you can say when you look at a scene is "That's interesting," then you should rethink your photographic approach."

"I photograph with my brain, not my camera," quips Lynch. "I try to be as analytical as possible when I'm shooting in the field. It is easy to get seduced simply by the charisma of a subject, its flamboyant colors, or its rarity. For example, a photograph of a wild wolverine is extremely rare, but a bad photograph of such a subject is still a bad photograph no matter how rare it is.

It took me years to learn when not to shoot. You can be in an exotic locale, surrounded by exotic subjects, but there still might be no photograph. If all you want is simple documentation, then fire away, but most photographers strive for more than this. I never get discouraged when I am in the field because I view every outing as an opportunity to learn something new, which I believe will ultimately make me a better photographer in the future."

Oxalis oregana flowers and leaves and Mahona nervosa leaf, Portland, Oregon
Nikon FA, Nikon 200mm macro lens, Fuji Sensia
Ken Meyer

I used a 200mm macro lens for this closeup. The focal length enabled me to work at a comfortable distance, and its narrow angle of view isolated the important elements of the photograph.

OPPOSITE PAGE
Texas wildflowers, Hill Country west of Austin, Texas
Canon A2, Canon 90mm TS lens, Fuji Velvia
Weldon Barfield

To photograph these Texas wildflowers I used the tilt feature of Canon's 90mm TS lens. This let me maximize foreground-to-background sharpness at a wider aperture and faster shutter speed than a conventional lens would offer. These settings also minimized the effects of the wind.

Sandhill cranes at sunset, San Joaquin Delta, central California
Nikon N8008s, Nikon 300mm lens, Kodak E100SW
John M. Stark

While photographing sandhill cranes at a local refuge in the San Joaquin Delta of central California, I noticed the cloud formation in the west. With a 300mm lens I framed the cloud and waited for the birds to return to their roosting area. As luck would have it, I didn't have to wait long.

BELOW
Wild grasses and sun, Loudoun County, Virginia
Nikon F5, Nikon 600mm lens + 1.4X teleconverter, Fuji Astia
Christopher Leeper

I framed these wild grasses against the setting sun near my home using my 600mm lens and 1.4X teleconverter. They provided just the right magnification of the sun's image. To ensure that the aperture blades didn't register on film, I shot with the lens wide open.

WHERE TO BEGIN

You decide to get right to the heart of the matter: "Any advice on getting started as a pro?"

Shaw begins: "Remember that a 'pro' photographer is one who is 'professional.' This is someone who runs a successful business, and the bottom line in business is to show a profit. One of the biggest fallacies is that a large gross income equates with a successful business. It doesn't. Net income, or 'what's leftover after all your expenses' is all that counts. It is easy to earn $10,000 if you spend $20,000 doing it!

In photography it is easy to spend money. That new 600mm F4 lens that you just absolutely need . . . well, it's about $10,000. That trip to Kenya you've always wanted to take . . . there's another $4,000 or $5,000. Oh yes, how about film and processing? Shoot 1,000 rolls a year, and you've spent around $12,000. I know lots of 'professional' photographers who gross big bucks but spend even bigger bucks in doing so. Remember, a business should show a profit.

One solution is to keep your overhead low. Make do with the equipment you already own by working with it to the fullest possible extent. Have your office in your house. Differentiate between trips for fun and business travel. Stay at a Motel 6 rather than a Marriott unless someone else is picking up the tab. Don't spend money unless you can justify how the expense will positively make you more money."

Lynch hesitates for a moment, deciding whether he should reveal the "big secret to success." Smiling, be begins: "The big secret about getting started as a nature photogra-

Moth on tree bark, Salt Creek Recreation Area, Washington
Nikon N90s, Nikon 105mm macro lens + extension, flash, Fuji Velvia
Terry Wallace

While walking back to my campsite at the Salt Creek Recreation Area near Port Angeles, Washington, I found this magnificently camouflaged moth. I set up two flashes on a bracket, which enabled me to handhold the camera.

Sand patterns with sand dollars, Pine Point Beach, Scarborough, Maine
Nikon 90s, Nikon 105mm macro lens, Fuji Velvia
Brian George Scanlan

I find the 105mm focal length perfect for framing intimate portraits of the natural environment. In this shot, the low angle of the light just after sunrise gave the sand and shells texture and detail not clearly visible at other times.

pher is that there is no big secret. It's plain common sense. First of all, don't quit your day job, otherwise how will you feed your cat, buy toilet paper, or pay for your cable channels? Second, work locally, and become an expert in your home state or province. I've photographed wildlife on every continent on earth yet the photographs I sell most often are those I made in my home province of Alberta. By concentrating on areas close to your home, you can establish a reputation with local agencies, build a valuable network of contacts, and readily take advantage of chance opportunities without incurring tremendous expense."

Middleton adds: "I think the biggest misconception about being a pro is that money is earned in the field. Actually, money is *spent* in the field; it is *earned* in the office. This is never what people want to hear. They're earning money in an office right now, but they want to be earning money sitting in a blind or chasing sunsets.

"Aspiring pros want to know how they can spend all their time in the field and still have checks appear in the mail. Unless you know some magic, it isn't going to happen. Checks appear only when you spend the time in your office earning them. The more time you spend in the office, the more money you'll make. Office time means making submissions, calling people, doing research, writing articles, developing slide shows, labeling slides, etc. The tedium of doing this stuff is what pays; the glamour of being out in the field almost never does.

"The other part of this is to become a student of the printed page. Linger at newsstands, bookstores, and libraries looking over every magazine or book you can get your hands on. How else are you going to know what your peers are doing and what a particular magazine has published lately? It isn't very glamorous, but the more information you have the better you'll be at earning money."

Reflection in pool, Yellowstone National Park, Wyoming
Nikon F4, Nikon 35–135mm lens, Fuji Velvia
Calvin Rone

*I drove past this pond twice, until finally the right light was available. The early-morning illumination gave
me the subtle colors that made the image work. I used my 35–135mm zoom lens to isolate sections.*

LEFT
Burned forest and flowers, Yellowstone National Park, Wyoming

Ted Nelson

MAKING A LIVING

Feeling slightly discouraged, you decide to take a different tack: "What are the biggest myths about making a living as a nature photographer?"

Shaw practically leaps at this question: "Here's the nature photographer's fantasy: *National Geographic* is giving you a six-month assignment to photograph your favorite National Park, shooting any aspect of it you want in any manner you wish. Pay is $10,000 per month plus all expenses. When they finish using the photographs, you plan on self-publishing a book and calendar from the shoot. You'll be on "Easy Street" for life.

"Don't start packing for that move just yet. First of all, almost no professional nature photographer makes a living working on assignment. In truth there are very few assignments for nature photographers at all. Almost all work

Cloud over Mt. Rainier, Eatonville, Washington
Nikon F4, Tamron 80–200mm lens, Kodak Lumiere
Ronald G. Warfield

I began shooting this altocumulus, stacked lenticular cloud over Mt. Rainier at noon. Five hours later, the setting sun warmed the scene and I zoomed to a focal length of about 155mm in order to isolate the cloud and mountain.

today is stock (you already have the shots in your stock file) and marketed on speculation. Assignments are usually self-generated and self-financed.

Think long and hard before committing to self-publishing. To have 10,000 copies of a book printed with full-color plates, you should plan on spending at least $6 or $7 per copy. Now what? All those books are sitting in your garage. How do you market them, and where do you distribute them? Having both a marketing and a distribution plan in place is the starting point and not the final consideration of self-publishing."

"It's time to burst another bubble," jokes Lynch. "Today, the average nature photograph used in magazines, books, and calendars often sells for less than $250. Many publishers, in fact, expect to pay half that much when they buy multiple images from a single photographer. So maybe

you better cancel that new four-wheel-drive Jeep you just ordered. In 1998, my wife, Aubrey, and I spent April and May in the field in Alberta and Saskatchewan and spent about $3,000. I don't know how we could have done the trip any cheaper. To break even we had to sell at least a dozen photographs from that trip, and it took us almost a year to do that. Another trip we made several years ago to the Andes Mountains of northern Chile cost us more than $6,000. To this day, we still haven't sold a single photograph from that trip."

Frustrated that his colleagues are suddenly so talkative, Middleton finally jumps in: "This is the myth that I really like: pros get free film and gear and all kinds of special treatment. It's true that some well-known pros do get to

Spider and web, Cades Cove, Great Smoky Mountains National Park, Tennessee
Nikon F4, Nikon 105mm macro lens, Fuji Velvia
Joe Bailey

I was out scouting locations on a cold, frosty morning in Cades Cove when I found this spider. I'd planned on shooting scenes and frost, but this was too good to pass up.

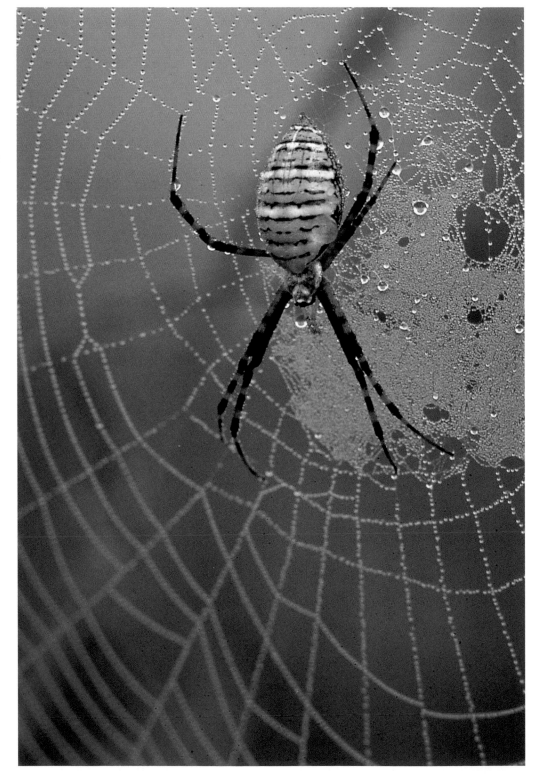

use gear if they agree to promote it, but most of their equipment and that of most other pros is purchased at the suggested retail price just like everyone else's. I wish I could get my gear free, but unfortunately Mr. Nikon, Mr. Canon, Mr. Gitzo, and all the other 'misters' out there want to make a profit just like I do. The special treatment part is also pretty silly. The reason you see the same names over and over again is because these people are able to consistently produce high-quality work. Publishers like that. Publishers don't like to waste their time with people who say they can do something and then not do it. If you develop a reputation for producing high-quality work consistently, then your work will be seen everywhere as well."

Fallen Japanese Maple leaves, University of Washington Arboretum, Seattle
Canon A2, Canon 28–70mm lens, Fuji Velvia
Stephen Matera

In late autumn I went to the University of Washington Arboretum in Seattle to photograph the fall colors. The leaves had fallen off most of the trees. I set my zoom lens at 28mm to show the blanket of fallen leaves and include a section of the trunk.

Mt. Katahdin in autumn, Baxter State Park, Millmocket, Maine
Fuji GX617, Fuji 105mm lens, Fuji Velvia
Deborah J. Schmidt

The long exposure required for my panoramic shot enhanced the dramatic pre-dawn colors of peak fall foliage and reflections in the Penobscot River. These contrasted well against a fresh snowfall on Mt. Katahdin in Baxter State Park.

RIGHT
Walker Lake sunset, Brooks Range, Alaska
Canon Ftb, Canon 50mm lens, Kodachrome 64
Mike Mullen

During a geologic field-mapping project, I was camped on the shore of Walker Lake in the Brooks Range of northern Alaska, an area that would become the "Gates of the Arctic National Monument." On a particularly calm evening, I was able to capture this scene approaching midnight after the sun had dropped below the horizon and the sun's afterglow was reflected in the lake's water.

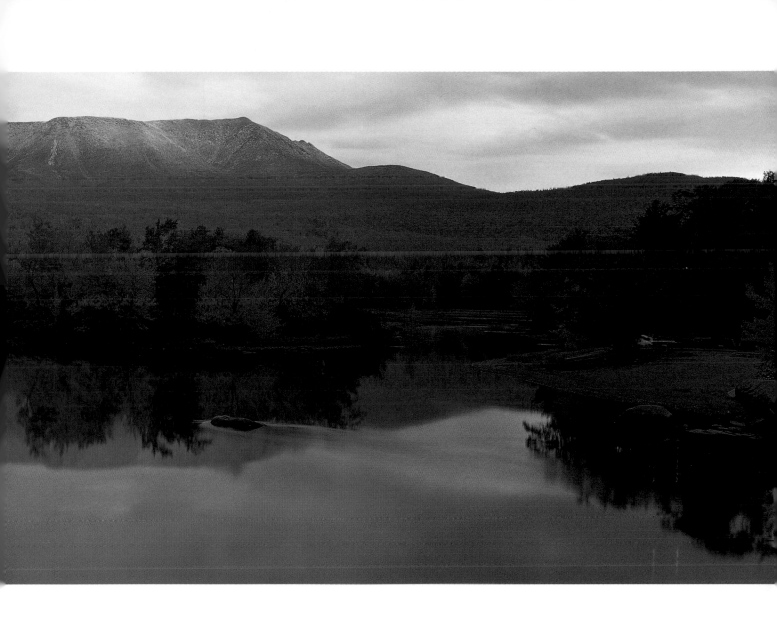

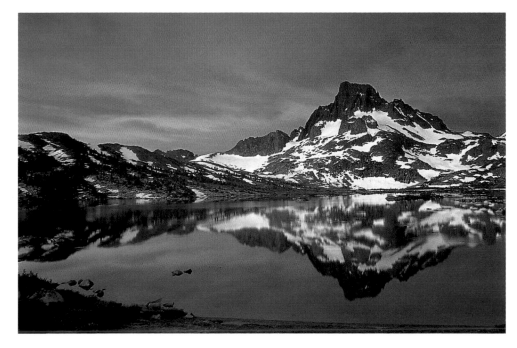

**Mt. Banner sunrise reflections,
Ansel Adams Wilderness,
Sierra National Forest,
California**
Canon EOS-1n, Canon 20–35mm lens,
Fuji Velvia
Bradford J. Haney

For three days, Thousand Island
Lake had been windswept and
uncooperative. I planned to move
out early that morning, but as I
broke camp at 4 A.M. the lake was
as smooth as glass. Using my
wide-angle zoom lens, I worked
to take in as much of the scene as
possible.

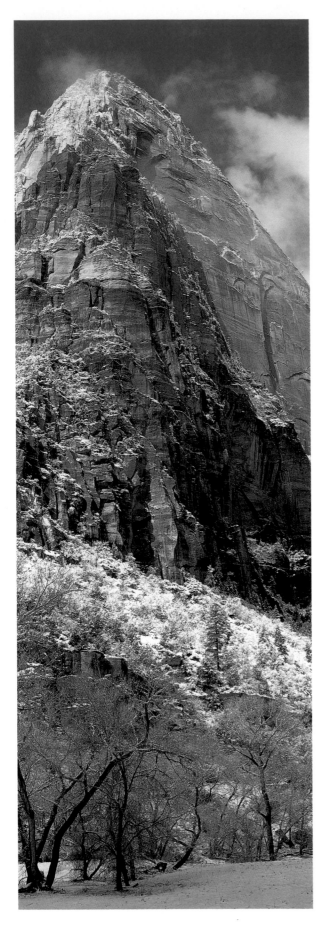

MASTERING TECHNIQUE

With a new rush of enthusiasm, you decide to stick with the simple questions: "How about some advice on technique for the aspiring pro?"

Middleton, rising to the easy bait, snags this one first: "Repeat after me: tripod, tripod, tripod. Use it for every shot you take even if it is a pain in the neck to use. Nothing will improve your photography faster than using a tripod faithfully.

"I'm not just talking about the improved sharpness of your photographs—and no, you can't shoot handheld at 1/15 sec. and get tack-sharp images. The biggest difference will be in your compositions. Precisely because tripods are a pain to use, they slow you down. The slower you go, the more deliberate you allow yourself to be. The more deliberate you are, the better your craftsmanship will be. The better your craftsmanship is, the better your photography will be.

"With a tripod you can consider your compositions, you can examine the edges and corners of your shot, and you can place objects in your compositions exactly where you want them. If you want something in the corner, then you can place it there. If you're handholding your camera, dollars to doughnuts you're going to place your subject dead center because it is the safest place for it, but dead center is, in terms of composition, almost always the dullest place for it."

Picking up steam now, Middleton continues: "The one time I don't use a tripod is when I'm looking for a shot. Then I take my camera off my tripod and wander around. Handholding my camera, I have the freedom and ease to move around and look at a potential shot from every possible angle. If my camera were on the tripod, it would be too inconvenient to examine a shot from every angle because I would spend all my time putting the tripod legs up and down. When you handhold your camera while you're looking for a shot, you end up having your composition determine your tripod height. But if your camera is mounted on your tripod while you're looking for a shot, you'll end up finding a composition that matches the height of your tripod."

Zion National Park in winter, Utah
Fuji GX617, Fuji 105mm lens, Fuji Velvia
Deborah J. Schmidt

Driving through the dramatic Zion River Valley after a fresh snowfall is an awesome experience. Using my panoramic camera in a vertical format, I was able to capture the full expanse of this sunlit, snowcapped mountain, topped with a vivid blue sky and swirls of windblown snow at the peak.

Lynch jumps in: "A light meter makes a very good servant but a very poor master, so don't be a slave to your light meter. I don't care how sophisticated you think the metering system in your camera is, it is still a simple-minded machine compared to the human brain. I've been photographing for 28 years, and for 28 years I've manually metered every exposure I've ever taken. The meter in your camera sees only light and dark. It doesn't know which part of a scene or a subject is important, and which isn't. Why then would you let your camera decide how to expose the scene?"

Finally, Shaw elbows his way into the conversation: "Without a doubt, good photographic technique is more important than the brand of camera you use or how much that new lens cost. Use a tripod, shoot static subjects with a cable release, focus carefully and accurately, don't stack every filter you own, and determine exposures thoughtfully and precisely. Quality in technique equals quality in the results.

"I've heard it said that you need a 4 x 5-inch view camera to make it as a professional. Not true. While some pros certainly use this format and produce some incredible photographs, you can make great pictures with any format camera. Most view-camera shots are broad landscapes, for which that kind of camera is ideally suited. Medium-format cameras (6 x 7cm, for example) offer quite a bit of film image, but don't lend themselves to action shots, long lens use, or extreme closeups. Most working pros shoot with 35mm SLR cameras along with any other format they might use. In fact, I would venture to say that the vast majority of photographs in books and magazines are taken with 35mm SLR cameras. They have an extensive range of focal lengths available, have built-in motor drives, and are easy to handle."

TOP
Sunrise, Lake Tawakoni, Hunt County, Texas
Nikon F3, Nikon 28-85mm lens, Fuji Velvia
Lance Varnell

I arrived at this spot early one morning after scouting the area the night before. The first shots I took of the sunrise were average at best. But as the clouds and the colors continued to change, my wait paid off.

BOTTOM
Schwabacher Landing, Grand Teton National Park
Nikon N90, Nikon 24-50mm lens, Fuji Velvia
Chuck Summers

As the sun began to sink behind the Grand Tetons, I set up my tripod and camera with a 24-50mm lens. The warm light made the already spectacular scene before me even more beautiful.

Cucumber tendril, Higganum, Connecticut
Nikon N6006, Nikon 60mm macro lens, Fuji Velvia
Deb Hager

By carefully positioning my camera I isolated the tendril of a cucumber plant against its leaf and deep shadow. This gave the image a three-dimensional quality. I photographed in the late afternoon, using a white diffusion disc to soften the light.

OPPOSITE PAGE
Closeup of cactus spines, Anza Borrego State Park, California
Nikon F4, Nikon 105mm macro lens, Fuji Velvia
John Cang

Attracted by the colorful spines and the woolly material at their base, I decided to come in close for an abstract composition. The overcast sky, ideal for Velvia film, provided even lighting and saturated colors.

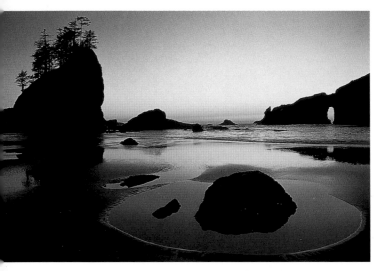

Third Beach, Olympic National Park, Washington
Olympus OM-4T, Sigma 24mm lens, Fuji Velvia
Mike MacDonald

To tell the story of the receding tide at Third Beach, the solitary pool of water and protruding rock seemed to provide the perfect foreground. I chose a wide angle of view to relate this inanimate foreground to the power and majesty of the larger landscape.

RIGHT
Seastacks at sunset, Bandon, Oregon
Gowland 4 x 5, Nikon 210mm lens, Fuji Velvia
Michael Wang

I paced the beach at Bandon, Oregon, at sunset, searching for an elemental image of rock, surf, and sky. When a band of clouds moved behind three silhouetted seastacks, I set up my view camera and quickly composed as my tripod sank into the wet sand. Just as an incoming wave revealed its jade underbelly and a gull alighted on a seastack, I tripped the shutter.

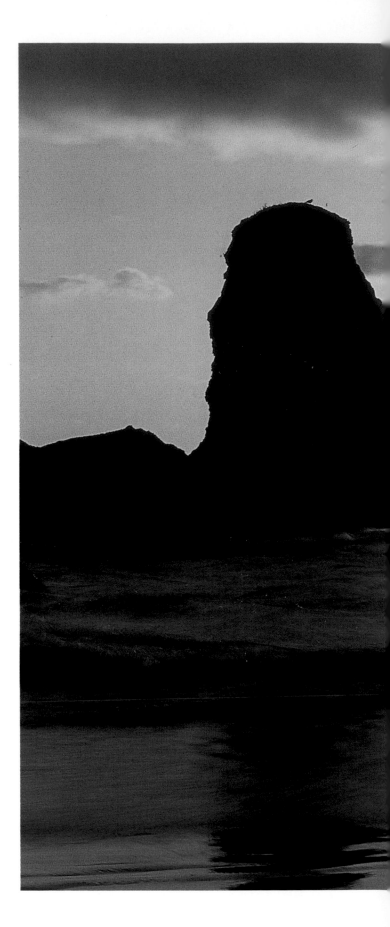

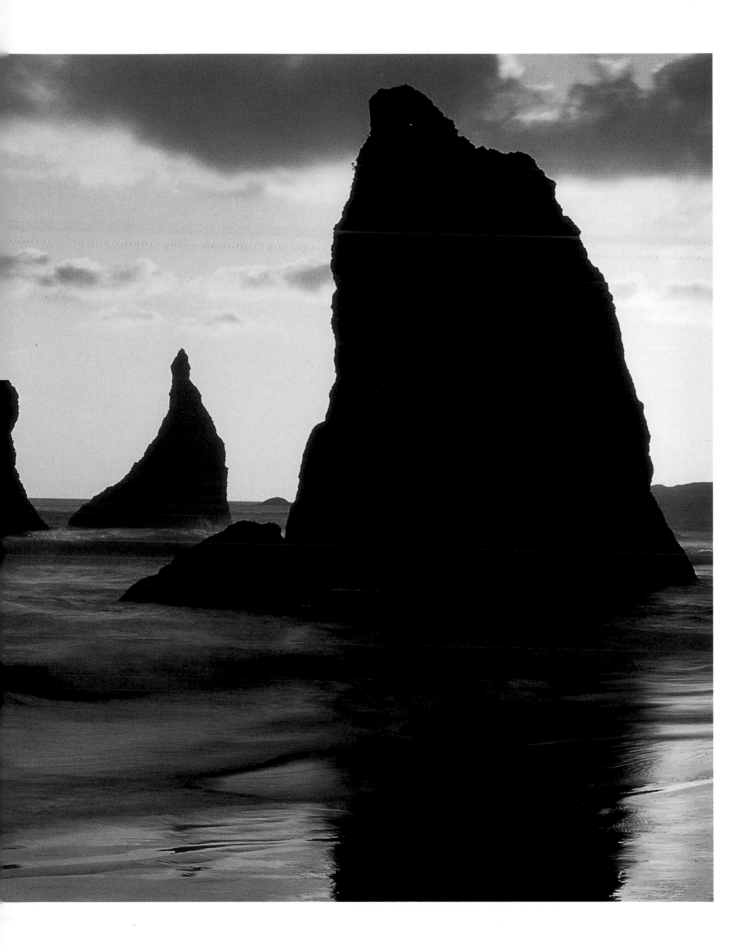

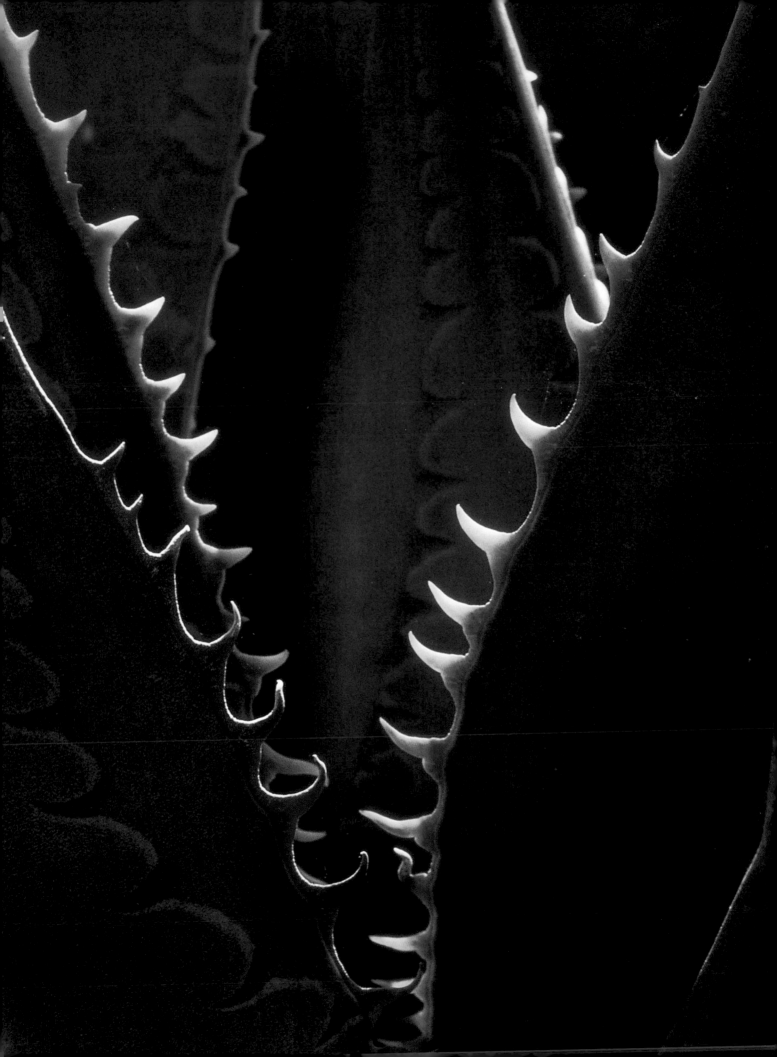

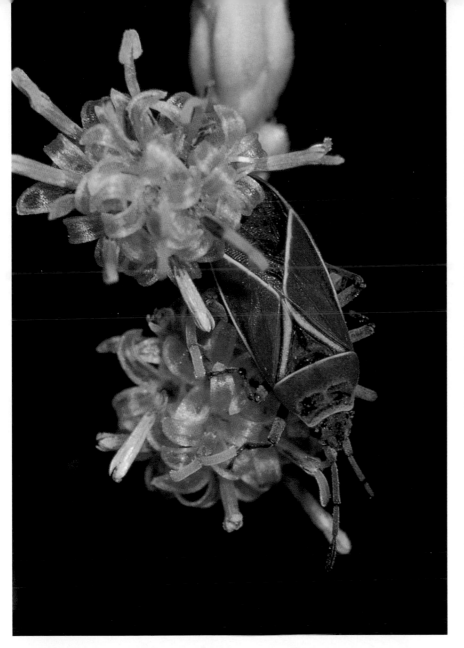

Plant bug, coastal hills, central California
Canon EOS 630, Tamron 80–210mm lens + extension and stacked Nikon 4T and 3T closeup lenses, flash, Fuji Velvia
Chris Dietel

Since the morning was still and the flower and bug were motionless, I chose a long shutter speed, with flash, to keep the distant background from turning out black. The flash brightened the subject and eliminated harsh shadows.

OPPOSITE PAGE
Shaw's Agave, Berkeley, California
Olympus OM2n, Tamron 70–210mm lens + extension, Fuji Sensia
Christine Kibre

I was walking through the succulent section of the botanical gardens in Berkeley, California, and was struck by the way the light was making the red, orange, and purple spines on this particular agave plant glow. I added an extension tube to my 70–210mm lens in order to focus close and get an abstract design of zigzag lines and contrasting colors.

BELOW
Sunflower, Englewood, New Jersey
Nikon N90s, Tamron 70–300mm lens, Fuji Sensia
Eva Kahn

This rear view of a sunflower was taken on my front lawn on an overcast day. The lawn provided the dark green out-of-focus background, while an f/11 aperture ensured that the flower was tack sharp.

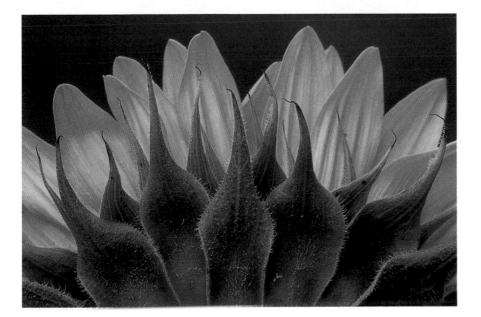

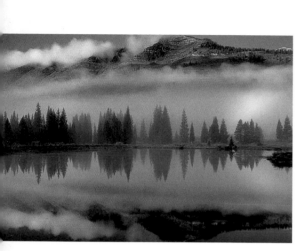

Morning mist, Crested Butte, Colorado
Nikon 90s, Nikon 20-35mm lens, Fuji Velvia
Steve and Silvia Oboler

On an unusually overcast morning in Crested Butte, we found a small pond reflecting spruce in the early-morning mist. We struggled with the beaver lodge but chose to shoot at 28mm to maintain the symmetry of the trees.

RIGHT
Fog at Reflection Lake, Mt. Rainier National Park, Washington
Nikon N8008s, Nikon 28–70mm lens, Fuji Velvia
Marie L. Mans

After I waited out a very foggy dawn at the lake, Mt. Rainier appeared out of the mist like a miracle. I photographed the reflection using a warming polarizer to bring out the sun on top of the mountain and counteract the blue light.

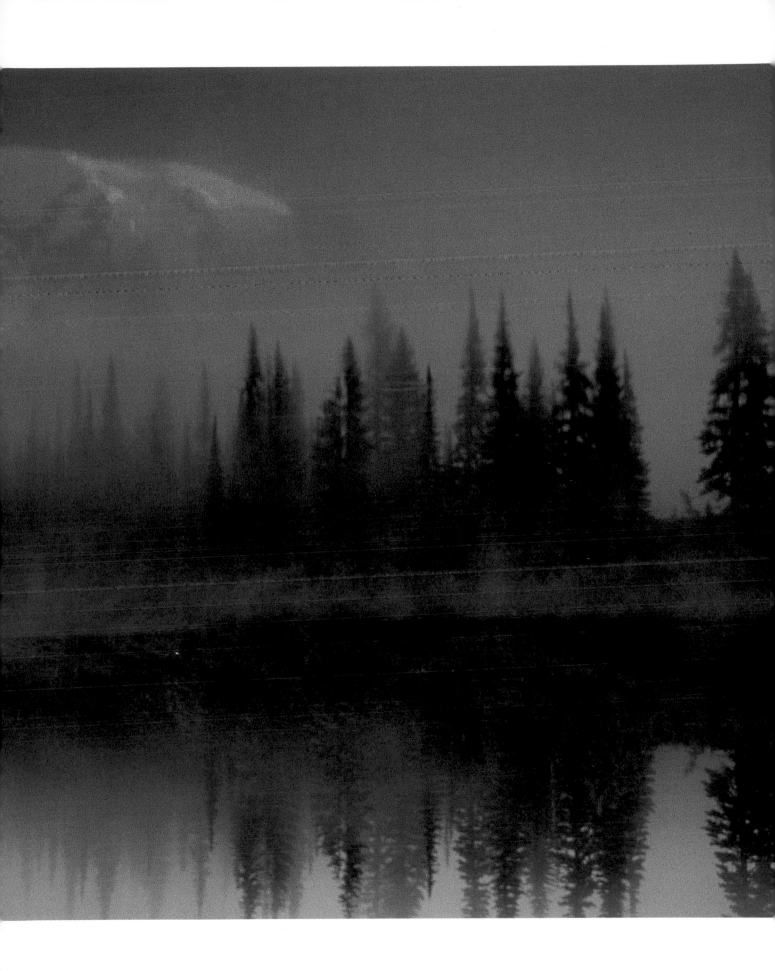

ESSENTIAL PERSONAL SKILLS

As the afternoon draws to a close, you decide to ask a final question: "Are any important personal skills needed to become a pro?"

Shaw grabs this one first: "A good reputation that is deserved is indeed priceless. Obtaining this status means doing nothing to diminish yourself. Be honest, be competent, and be professional. Don't tell editors you have all the shots when you don't. Don't be satisfied with the mediocre. Don't run down other photographers. Don't be sloppy in your office habits.

"Run an office in the same manner in which you would like to deal with an office as a client. Present a professional image. Keep a Rolodex listing of contacts, and return telephone calls promptly and courteously. Label your slides neatly, legibly, and correctly. Use a computer and printer for all written materials, including slide labels. Learn to package submissions so that editors can easily do their work.

"Here's how to make an editor your lifelong enemy. Put your name on the reverse side of your slides, using a Magic Marker and longhand script. Give each picture a cute title, and use fuchsia labels on the front side. Make checkerboard arrangements of the images when placing the slides in a slide sheet. Randomly insert horizontal and vertical images into the slide sheet so that the editor must continually flip the page to view the images. Fold the slide page over, and staple the edges together. Wrap the slide pages in paper towels, then place your submission in a box filled with Styrofoam peanuts. Include a letter written on spiral-bound notebook paper. Not to worry . . . you'll never sell a picture."

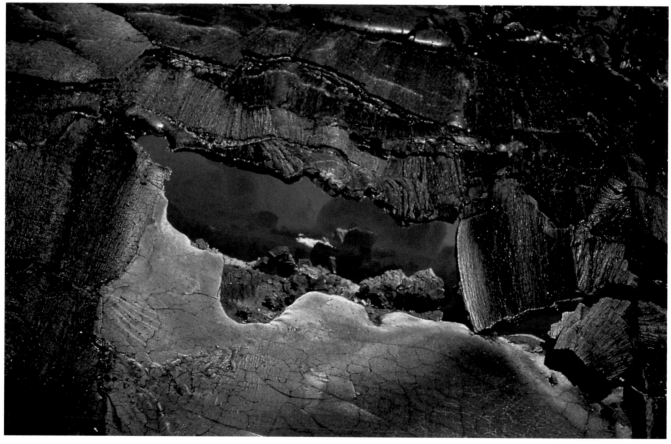

Skylight in lava tube, Volcanoes National Park, Hawaii
Nikon EM, Nikon 75–150mm lens, Kodak Ektachrome 200
Carol J. Phelps

On a helicopter tour over Kilauea's early activity, most of my pictures were wide to depict vast impact. I shot this tighter image wide open at a 150mm focal length, focusing on the hardened, broken tube. The exposed molten lava within provided its own illumination.

OPPOSITE PAGE

Yosemite reflection, Yosemite National Park, California
Minolta SRT 101, Minolta 50mm lens, Kodachrome 25
Marie L. Mans

At Yosemite several years ago I found myself at the right spot at the right time—with "only" a 50mm lens. I bracketed several compositions, eliminating the sky and fitting the rocks and shrub into the reflection.

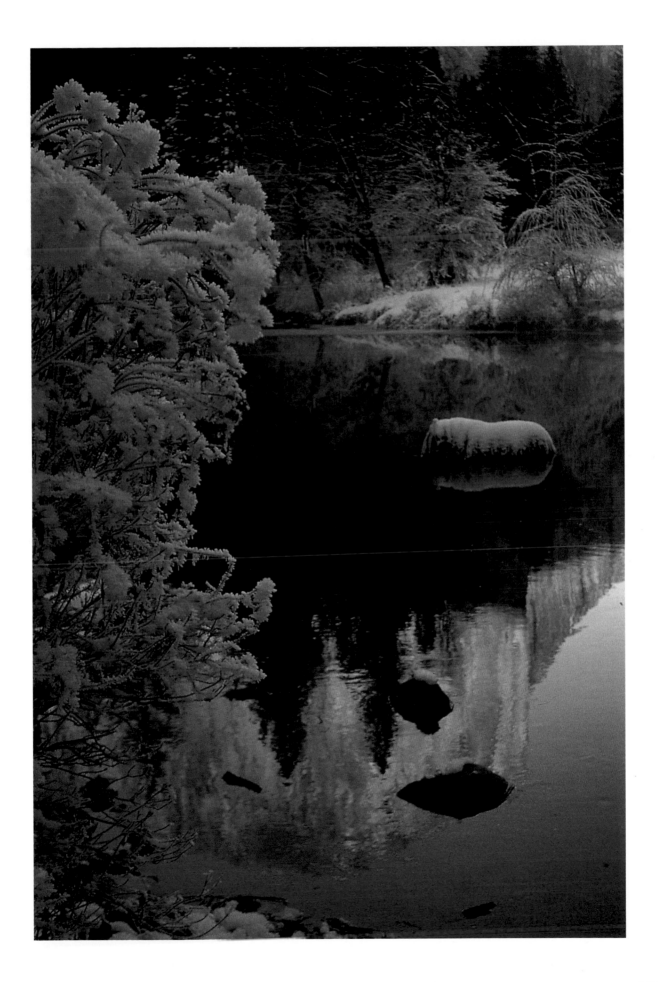

Lynch interrupts Shaw: "Try to be friendly, cheerful, and helpful on the telephone no matter how bad your day has gone. Editors are often overworked, stressed, frazzled, and generally behind schedule. If you can lighten their mood and make them laugh, even once, they'll likely remember your name and call you again some time in the future."

Middleton, now increasingly distracted by the growing sunset, adds: "Find a group of fellow photographers who you can network and interact with. It is too easy to become a little island and lose touch with whatever limited sense of reality photographers have. A peer group will keep you grounded, as well as be a great source of encouragement and inspiration.

Speaking of which, photography, like any of the creative arts, is rich in criticism and negativity, but poor in affirmation and reinforcement. Avoid negativity and shallow criticism while you treasure and cherish every positive acknowledgment you get, few as they may be at first. The affirmations will carry you through the long, dark periods of disappointment and self-doubt, and they'll remind you why you got into photography in the first place.

Affirmations also nurture your creative spark and let you stoke its fires brighter. Do nothing to diminish your creative spirit; it will be your guide throughout your life. Follow it closely.

Now, do you think we could go out and bag us a sunset? By the way, the beers are on you!"

Mitchell Canyon, California
Nikon N90s, Nikon 75–300mm lens, Fuji Velvia
Marcelo Alexandre DaSilva

I was hiking Mitchell Canyon when I spotted this lone tree. When I got close, I noticed that I could compose the photograph using the lines around the tree to keep the viewer's eyes focused on the main subject. I used my 300mm lens setting to crop out everything else.

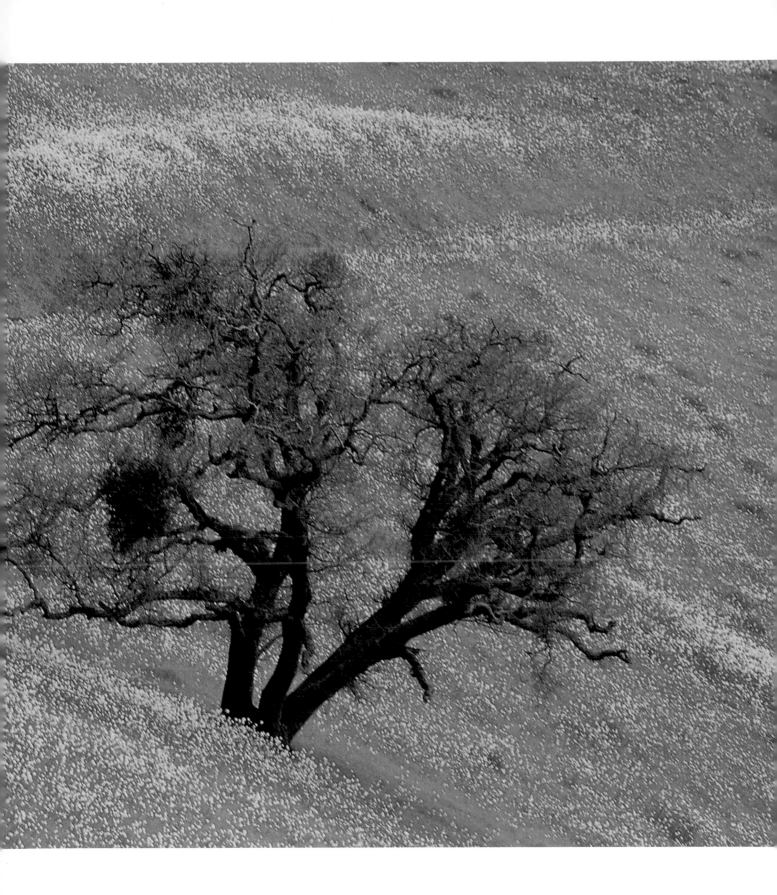

CONTRIBUTORS

Cathy Allinder
2605 Meckley Court
Virginia Beach, VA 23454

Ken Archer
P.O. Box 39748
Tacoma, WA 98439

Jane Ashley
8613 Cedarspur
Houston, TX 77055

Joseph Bailey
MSC 314
P.O. Box 917729
Longwood, FL 32791

Mark D. Baker
3701 Burlington Drive
Norman, OK 73072

Rod Barbee
2411 S 248th #D-11
Kent, WA 98032

Weldon Barfield
805 Cresside
Richardson, TX 75081

Cheryl Barnaba
679 East Main Street
Middletown, CT 06457

Kevin Barry
3320 SW 36th Street
Hollywood, FL 33023

Nancy Hoyt Belcher
6660 Simms Drive
Oakland, CA 94611

Wayne M. Bennett
973 Victoria Terrace
Altamonte Springs, FL 32701

Oliver Bolch
Donaustr. 113
A2344 Maria Enzersdorf
Austria

Gregor Busching
Carl-Reiss-Str. 19C
D67141
Neuhofen, Germany

Alan Caddey
P.O. Box 367
Renton, WA 98057

James J. Callahan
45 Biehs Court
Oakland, CA 94618

John Cang
3209 Heritage Point Court
San Jose, CA 95148

Ken Canning
2 Wagon Drive
North Reading, MA 01864

Steve Carlisle
4376 Rose Valley Road
Kelso, WA 98626

Bill Castner
5568 Stonewall Place
Boulder, CO 80303

Ken Chiles
811 Sanford Day Road
Knoxville, TN 37919

Maryellen Cole
99 High Street
Reading, MA 01867

Elizabeth (Libby) Collins
65 Stirrup Lane
Riverside, CT 06878

Clark Crenshaw
4014 Upland Way
Garland, TX 75042

Marcelo Alexandre DaSilva
14 Marina Lakes Drive
Richmond, CA 94804

John B. Davidson
8324 Sanderling Road
Sarasota, FL 34242

Richard J. Demler
45 Manor Road
Princeton, NJ 08540

Chris Dietel
473 Chesapeake Avenue
Foster City, CA 94404

Dudley Edmondson
4302 Cooke Street
Duluth, MN 55804

Rodney Evans
263B County Road 750N
Neoga, IL 62447

Katherine Feng
P.O. Box 4597
Durango, CO 81302

Jean Furman
1119 Sky Hill Road
Bridgewater, NJ 08807

William R. Gates
24 D South Kingsbridge Place
Chesapeake, VA 23320

Lynn A. Gerig
R.R. #1
6417 Morgan Road
Monroeville, IN 46773

Ian Gould
Box 495
Port Clements, British Columbia
 V0T 1RO
Canada

Robert M. (Bob) Griffith
4801 S Bella Vista Drive
Veradale, WA 99037

Stanley Grigiski
171 SE 20th Street
Cape Coral, FL 33990

Darren Guyaz
1915 Pine Street, #4
Boulder, CO 80302

Deb Hager
86 Christian Hill Road
Higganum, CT 06441

Roy Hamaguchi
5050 Pinetree Circle
West Vancouver, British Columbia
 V7W 3A2
Canada

Bradford J. Haney
508 1/2 Avocado
Corona del Mar, CA 92625

Peter Hartlove
2829 Hartwick Circle
Longmont, CO 80503

Kenneth J. Howard
10 Woodside Court
San Anselmo, CA 94960

John Indelicato
2445 Maroon Bells Avenue
Colorado Springs, CO 80918

Eric Jamison
40 Shirley Street
Pepperell, MA 01463

Chuck Janus
521 North 11th Street
Box 980-566
Richmond, VA 23298

Leon Jensen
1525 Draw Street
Cody, WY 82414

Robert Johnson
3375 Keithshire Way
Lexington, KY 40503

John M. Juston
603-B NE 4th Avenue
Gainesville, FL 32601

Vera Kalnins
5999 Strome Court
Dublin, OH 43017

Allen Karsh
1924 Mount Zion Drive
Golden, CO 80401

Christine Kibre
955 Corbett Avenue #3
San Francisco, CA 94131

John Kingsolver
1022 N 3rd Street
Renton, WA 98056

Christopher C. Leeper
1029 South Ironwood Road
Sterling, VA 20164

Marlene Nau Leistico
4761 Westnedge, NW
Comstock Park, MI 49321

Steve LePenske
1307 13th Street, NE
Auburn, WA 98002

Ursula Leschke
3765 High Street #10
Oakland, CA 94619

Steve W. K. Lu
2/F, Lok Moon Commercial
 Centre
29 Queen's Road East
Wanchai, Hong Kong

Bruce Lytle
12874 SE 262nd Place
Kent, WA 98031

Mike MacDonald
1524 Lakeview Drive #232
Darien, IL 60561

Samuel R. Maglione
17 Leicester Lane
Trenton, NJ 08628

Marie L. Mans
11575 SW Crown Court #5
King City, OR 97224

Stephen Matera
908 N 48th Street
Seattle, WA 98103

Nancy McCallum
P.O. Box 330
Oxford, MI 48371

Ron McConathy
222 Foxfire Lane
Kingston, TN 37763

Ken Meyer
3541 SW Vermont Street
Portland, OR 97219

Kevin P. Mick
319 Stoner Avenue
Westminster, MD 21157

David L. Mitchell
301 Lafayette Street, Apt. A 204
Petoskey, MI 49770

Daniel Mohr
192 Rte. 526
Allentown, NJ 08501

Bruce Montagne
857 Union
Milford, MI 48381

Michael Montgomery
26024 SE 29th Street
Issaquah, WA 98029

Michael Mullen
1349 Old Canyon Road, #4
Fremont, CA 94536

Stanley Murawski, Jr.
154R Skeet Club Road
Durham, CT 06422

James Murray
4009 Falcon Lake Drive
Arlington, TX 76106

Tom Myers
2252 Bonhaven Road
Lexington, KY 40503

Gregory M. Nelson
25870 Strath Haven Drive
Novi, MI 48374

Ted Nelson
2018 Lone Wolf Lane
Canton, MI 48188

Ron Niebrugge
P.O. Box 1337
Seward, AK 99664

Susan Nielsen
P.O. Box 1474
Citrus Heights, CA 95611

Judith Norton
2639 Hope Lane W
Palm Beach Gardens, FL 33410

Steve and Silvia Oboler
1675 Kearney Street
Denver, CO 80220

Clyde Parrott
3070 Seneca Court
Columbus, IN 47203

James Perdue
3270 Hopewell Chase Drive
Alpharetta, Ga 30004

Gail Perkins
6604 Osceola
Indian Head Park, IL 60525

Chris Perri
1930 Tulare Way
Upland, CA 91784

William Petersen
107 1/2 S 11th Street
La Crosse, WI 54601

Carol J. Phelps
1128 Fern Street
New Orleans, LA 70118

Ian Plant
2800 Quebec Street NW #904S
Washington, DC 20008

Gisela Polking
Munsterstr. 71
D-48268, Greven
Germany

Erik Pronske
3901 Lakeplace Lane
Austin, TX 78746

Mervyn Rees
29 Eridge Gardens
Crowborough, East Sussex TN6
 2TB
England

James D. Ronan, Jr.
P.O. Box 220230
Anchorage, AK 99522

Calvin Rone
7809 Burke Avenue
Margate, NJ 08402

Brian George Scanlan
1509 Philadelphia Pike
Wilmington, DE 19089

Deborah J. Schmidt
405 Levenseller Road
Holden, ME 04429

J.R. Schnelzer
3897 Lindenwood Court
Loveland, CO 80538

J. Scott Schrader
P.O. Box 1170
Helotes, TX 78023

Ky Schroeder
387 Dollar Avenue
Weed, CA 96094

Martin Schwenk
Peter-Doerfler-Str. 17
89426 Wittislingen
Germany

Craig Clinton Sheumaker
250 Lowell Avenue
San Bruno, CA 94066

Steve Shuey
8662 New Salem Street, #74
San Diego, CA 92126

Reed Smith
11507 Silver Oak Drive
Oakdale, CA 95361

Ronald Smith
378 Woodsbend Drive
Elizabethtown, KY 42701

John M. Stark
312 Ravenwood Way
Lodi, CA 95421

Edmund W. Stawick
17100 Carwell Road
Silver Spring, MD 20905

Chuck Summers
166 Logan Street
Jellico, TN 37762

Ellie Tyler
6785 Saddleback Road
Joshua Tree, CA 92252

Steven Valk
14 Gardner Avenue
Middletown, NY 10940

L.F. Van Landingham
819 Lockhaven
Coppell, TX 75019

Linda Vannetta
2910 10th Street
Tampa, FL 33605

Tibor Vari
65 Peach Hill Court
Ramsey, NJ 07446

Lance Varnell
7018 Foxfield
Humble, TX 77338

Lisa Von Moll
574 Hobcaw Bluff Drive
Mt. Pleasant, SC 22964

Terry Wallace
15923 Highway 99 #B309
Lynwood, WA 98037

Michael Wang
5118 Juneau Road
Madison, WI 53705

Ronald G. Warfield
P.O. Box 157
Eatonville, WA 98328

Barbara Warren
523 Palmer Farm Drive
Yardley, PA 19067

Lloyd Williams
264 Ridgeview Lane
Boulder, CO 80302

Richard Worthley
4 Andrea Drive
Newburgh, NY 12250

INDEX